THE WAY WEST

PETER KAYAFAS

THE WAY WEST

afterword by Rick Bass

Purple Martin Press New York 2020

Was there a scheme to things after all, and the present just a little part of it, and a man so small he couldn't see it whole?…Far from things, from markets and stores and churches and soldiers and law and safety and all. Far from the way that was their way.

—A. B. GUTHRIE JR., *The Way West*

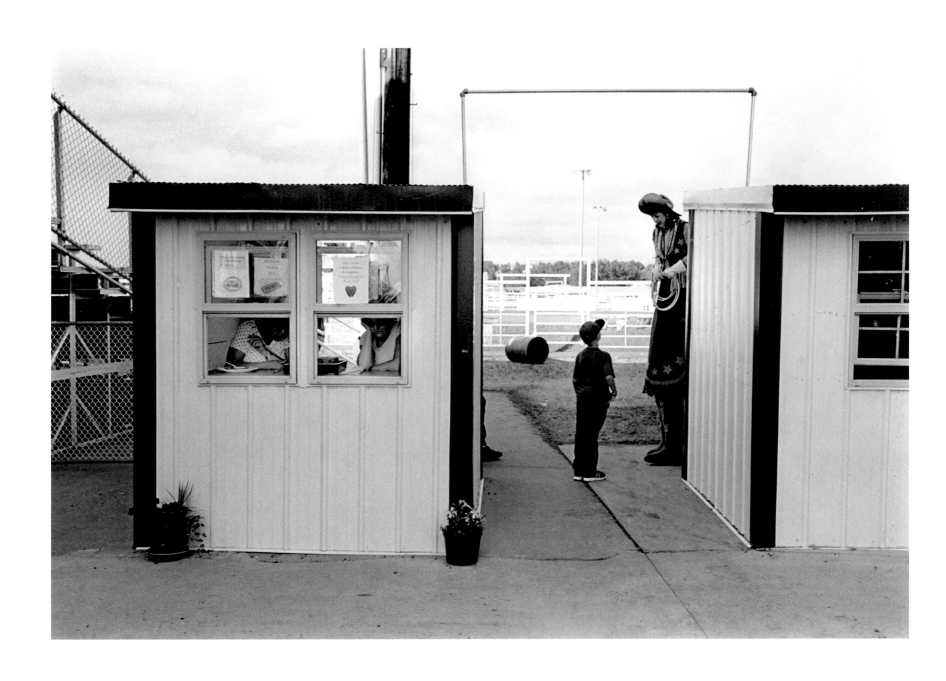

7

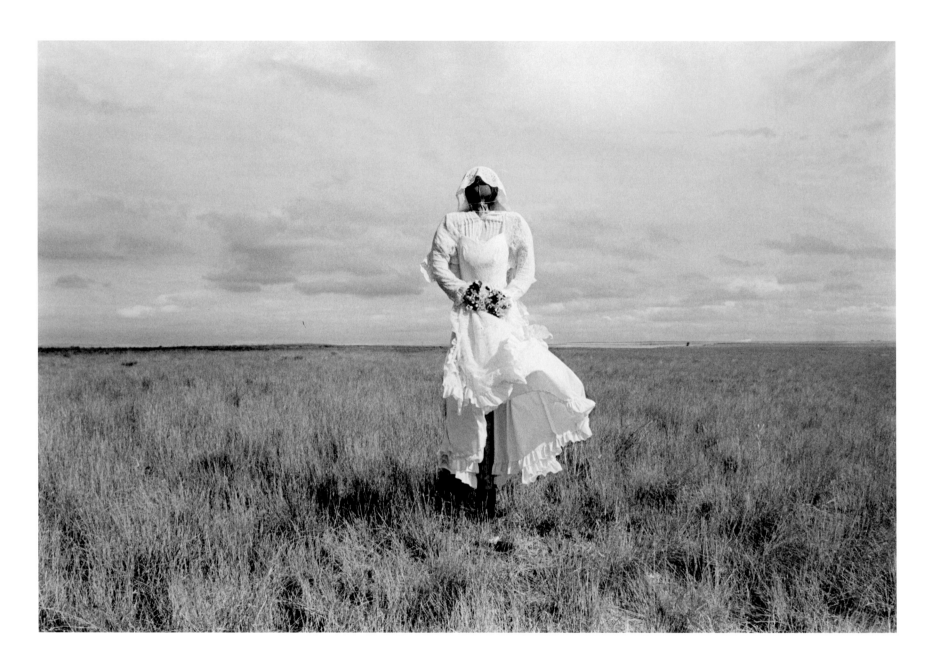

Liberty County, Montana 2015

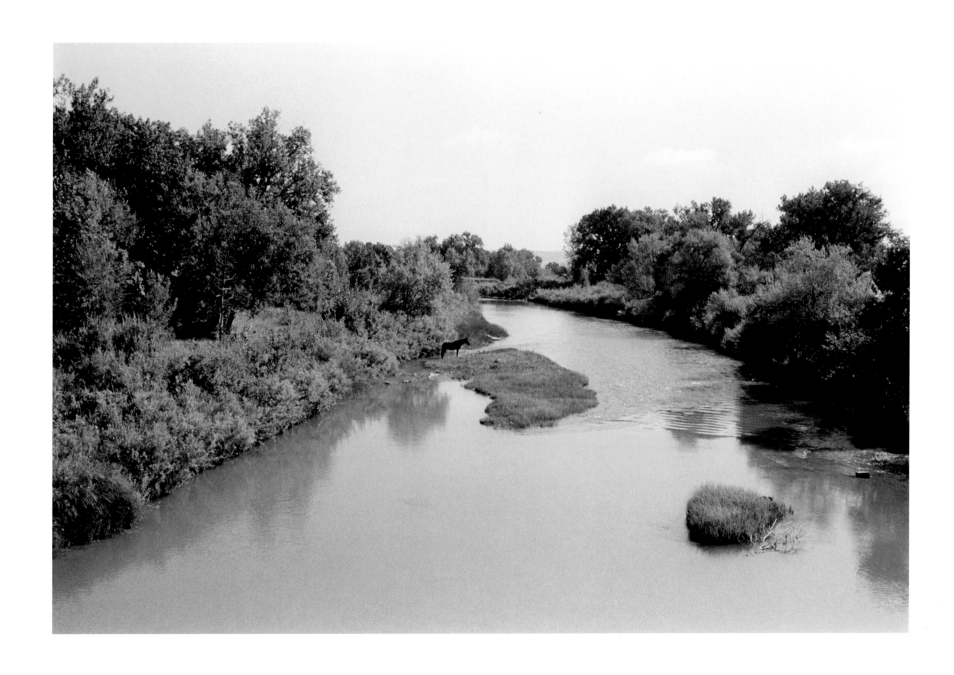

Crow Agency, Montana 2014

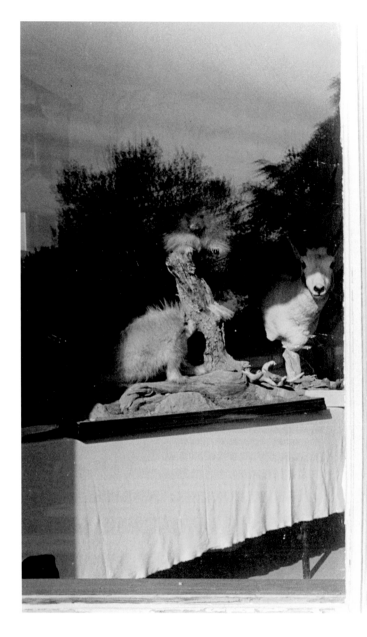
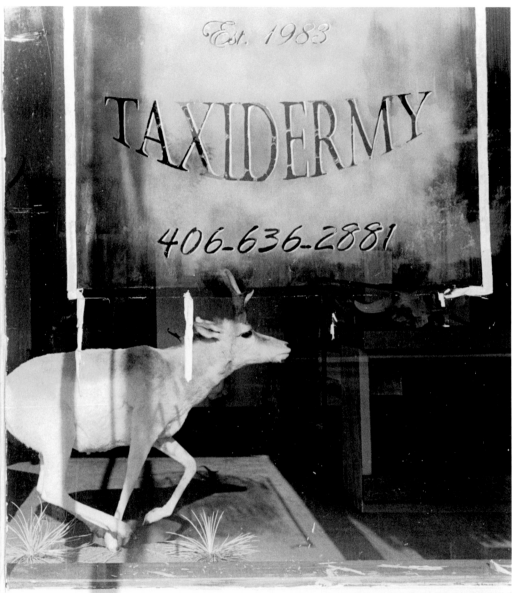

Lavina, Montana 2017

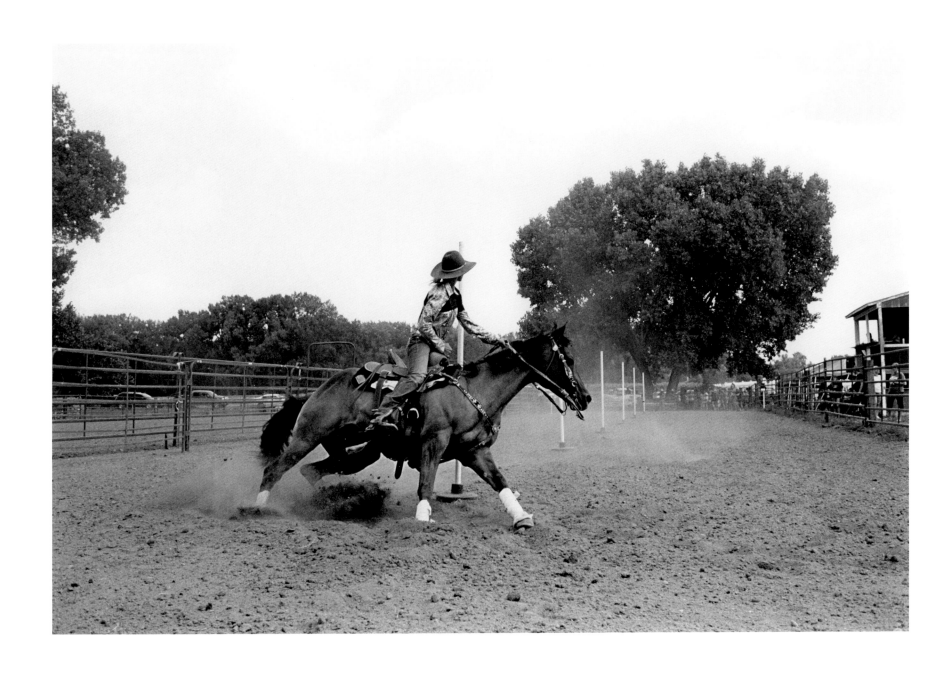

Sioux Falls, South Dakota 2014

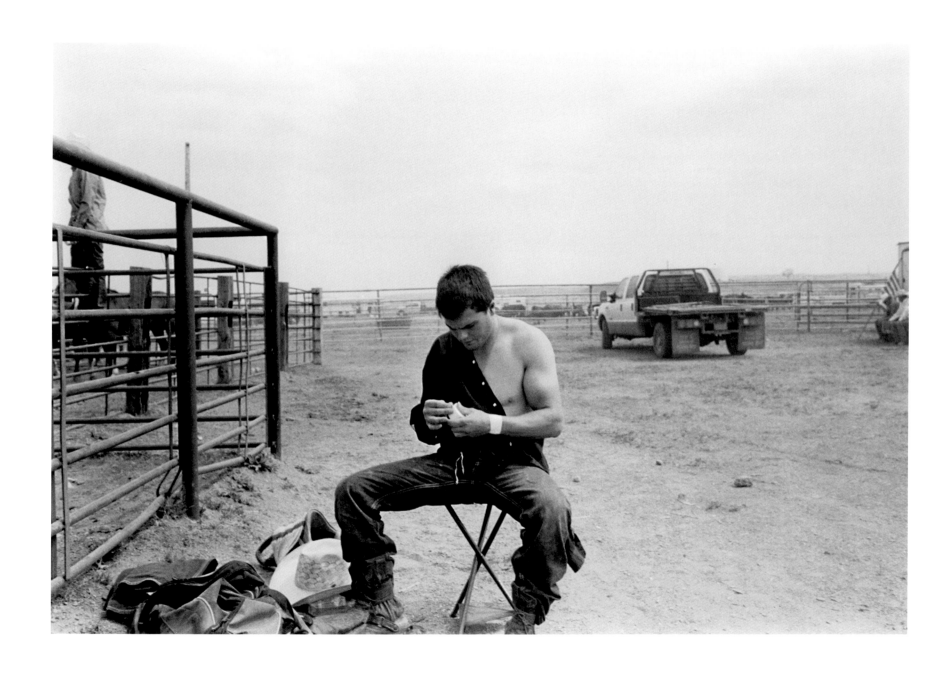

Crow Agency, Montana 2015

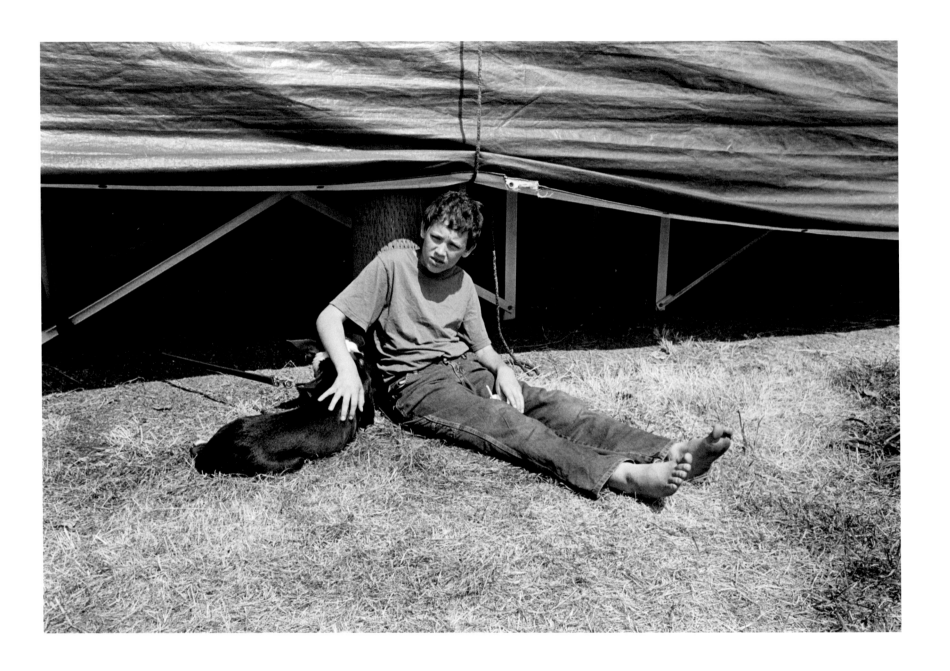

Twin Bridges, Montana 2017

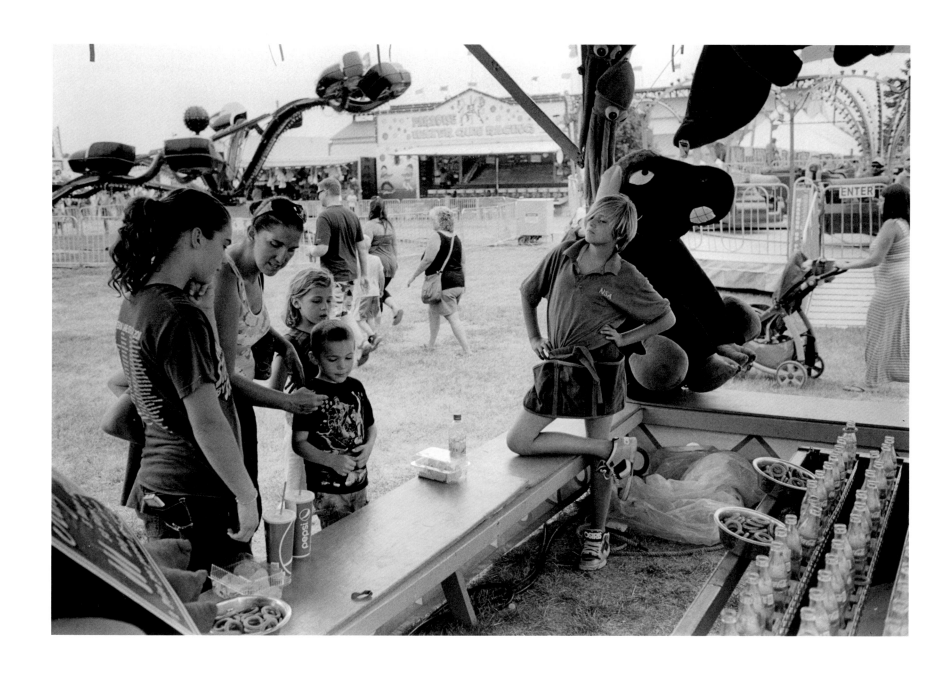

15

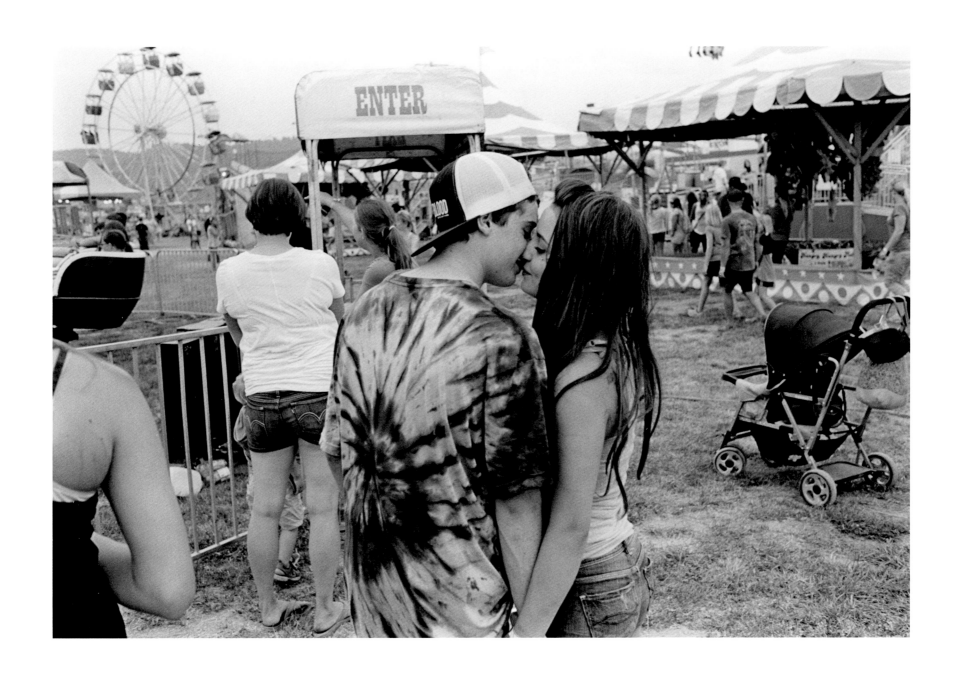

17

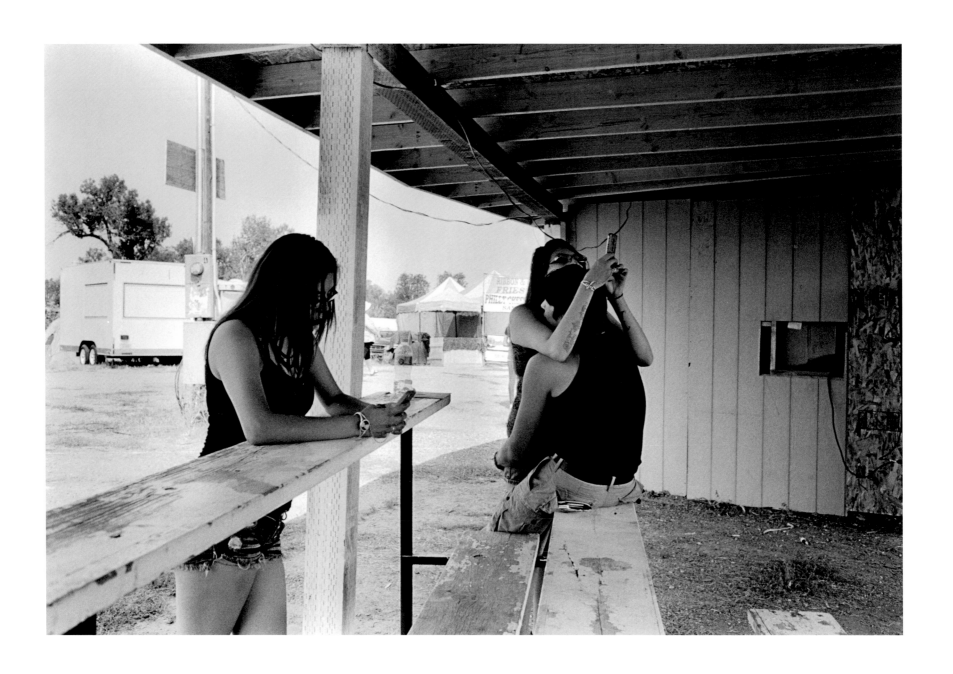

Crow Agency, Montana 2018

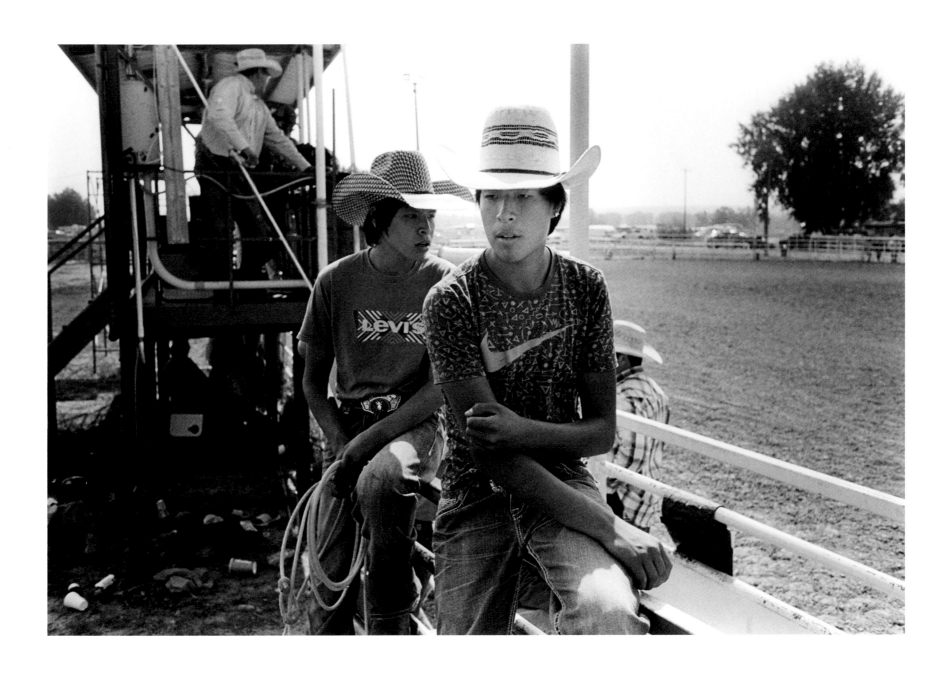

Crow Agency, Montana 2018

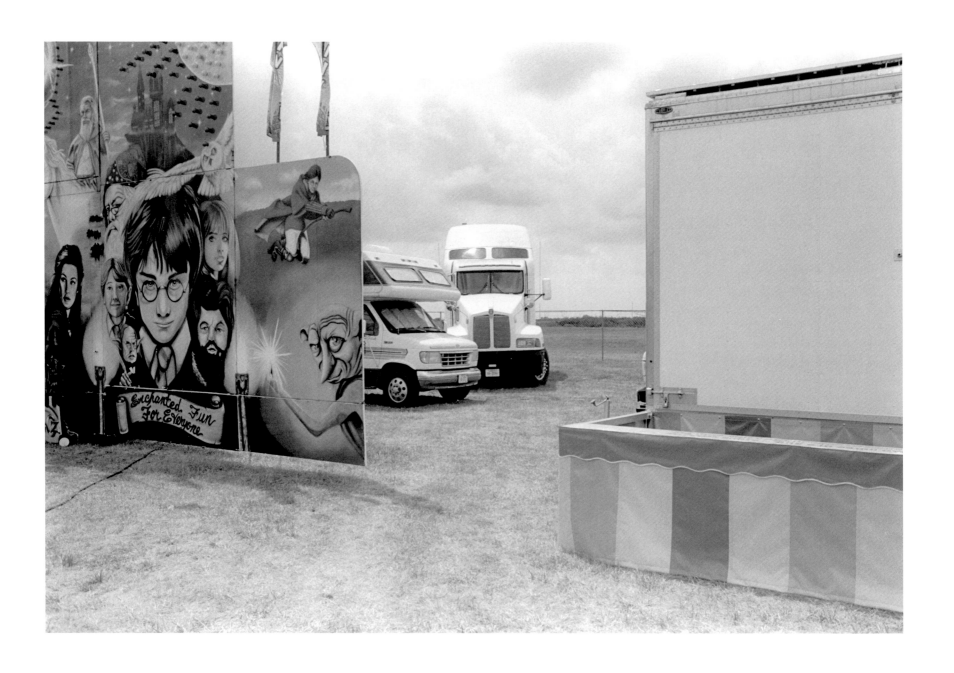

Aurora, Nebraska 2018

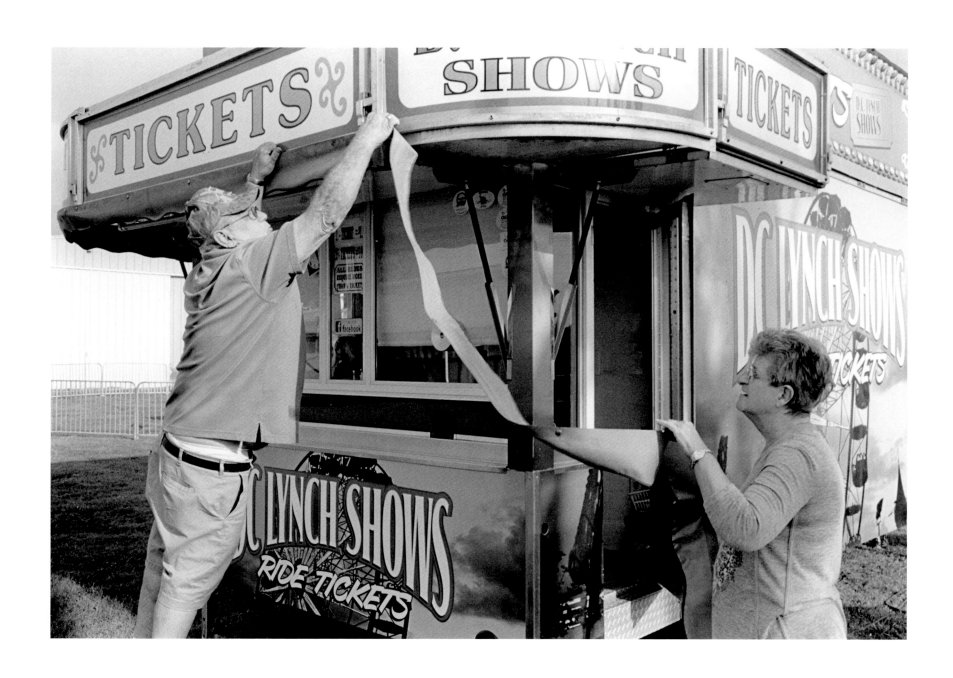

Central City, Nebraska 2018

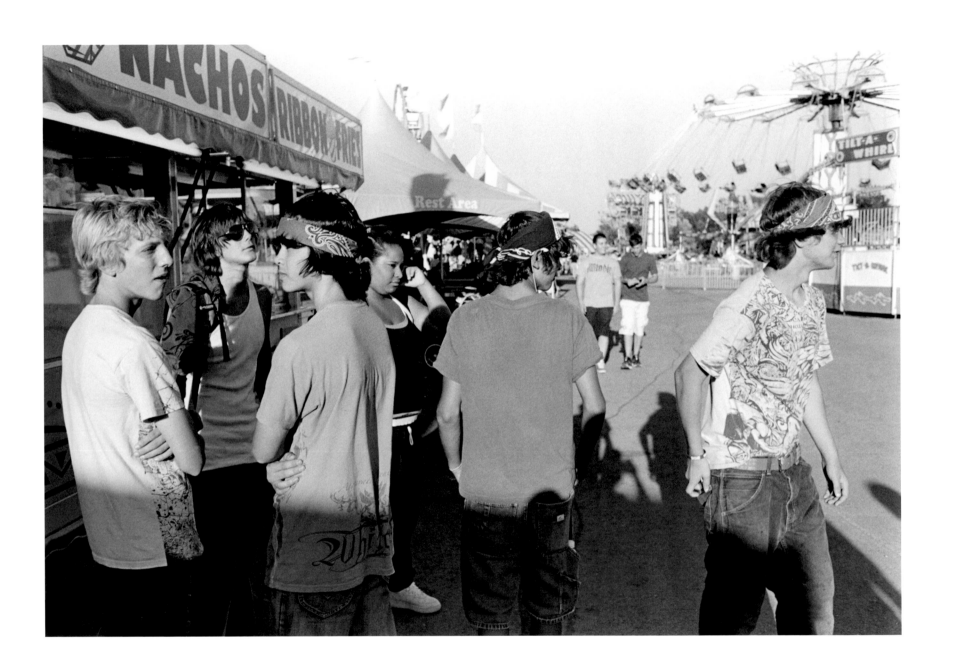

Rapid City, South Dakota 2010

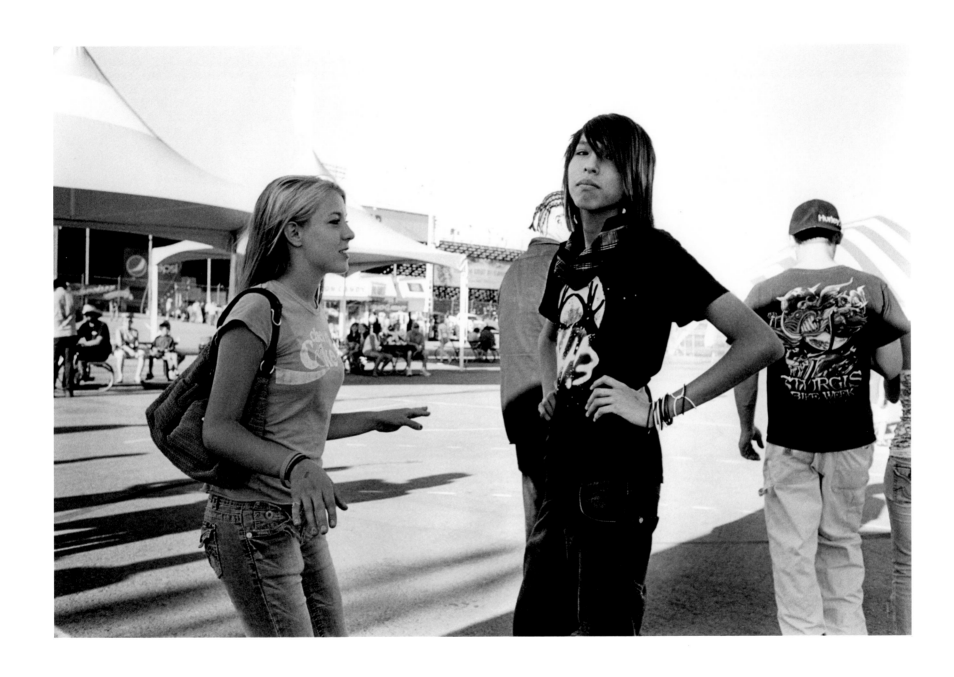

23

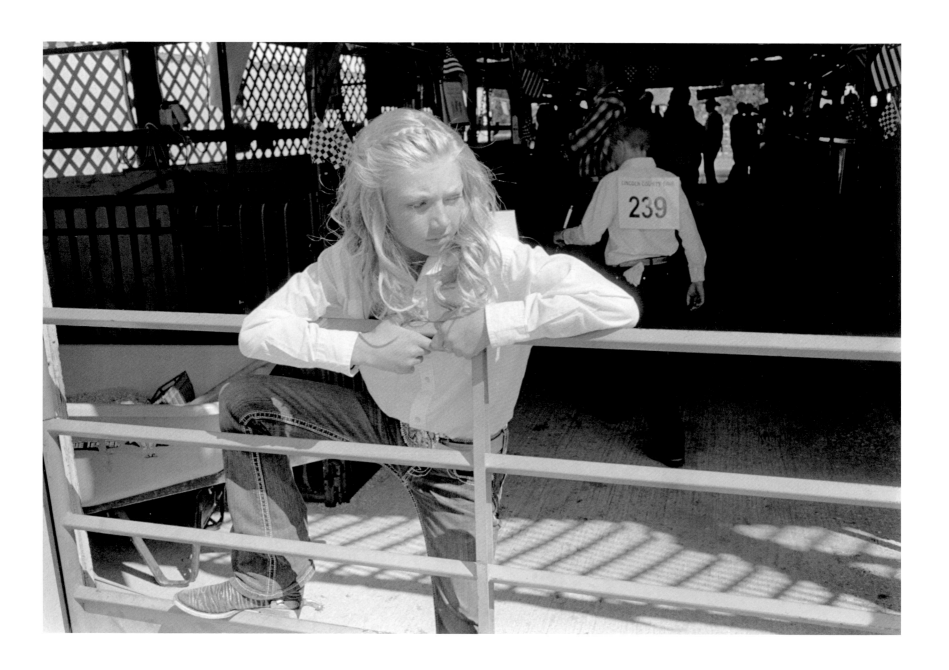

Afton, Wyoming 2016

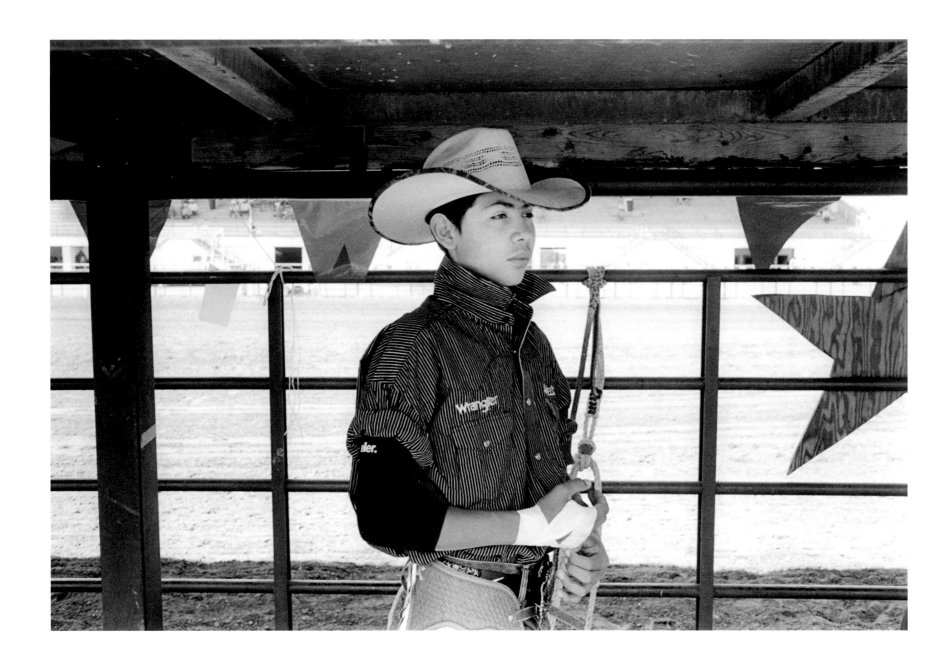

Crow Agency, Montana 2010

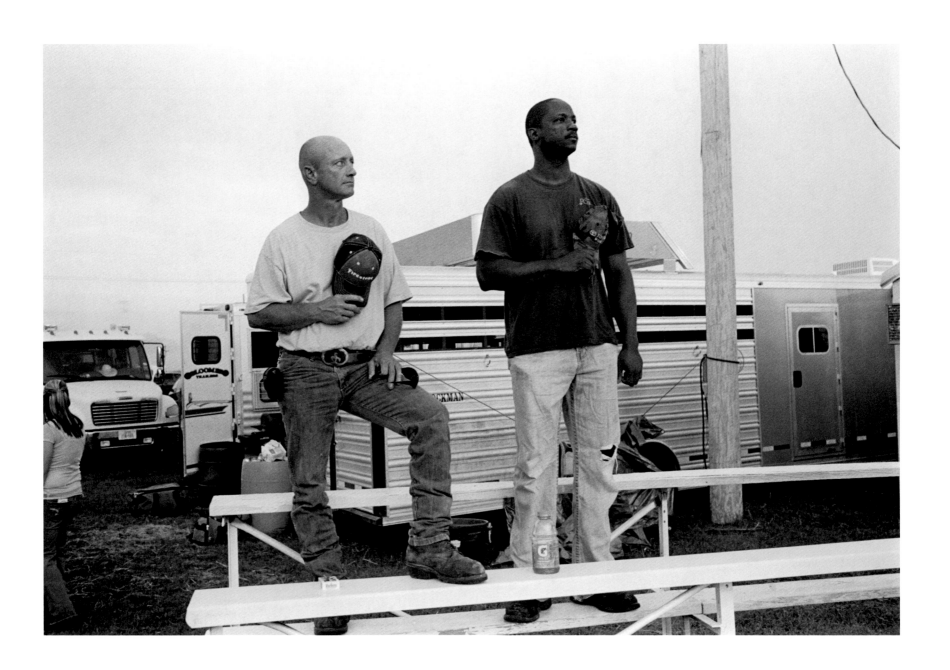

Waynoka, Oklahoma 2013

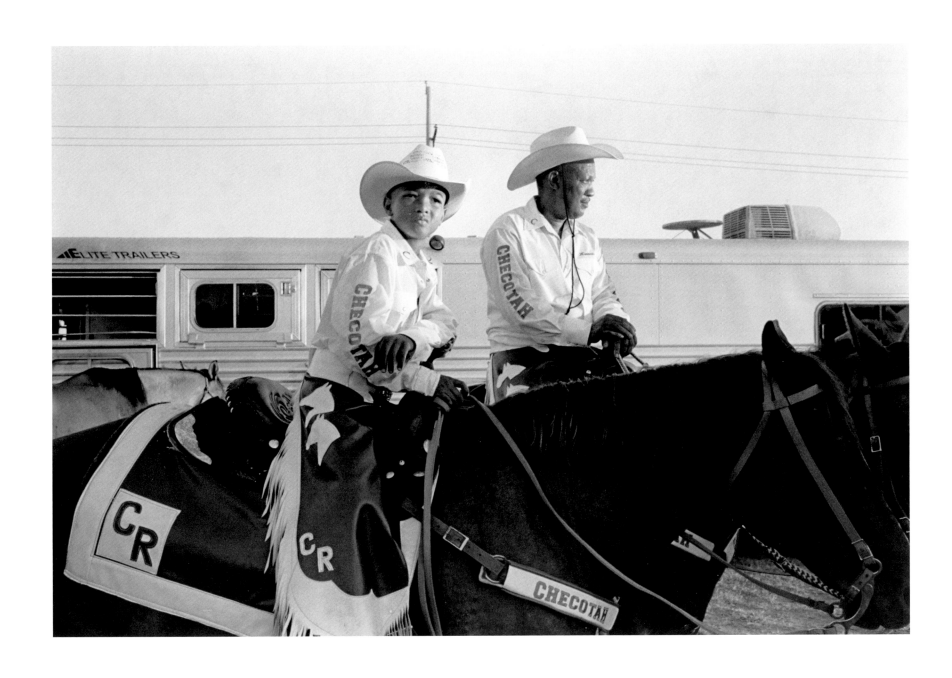

Okmulgee, Oklahoma 2015

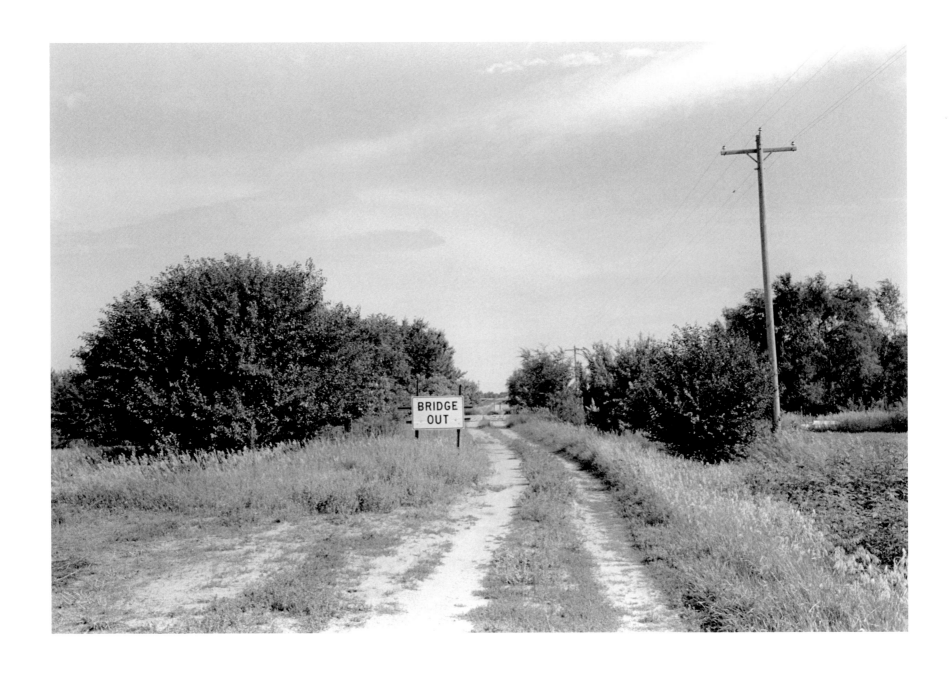

Merrick County, Nebraska 2018

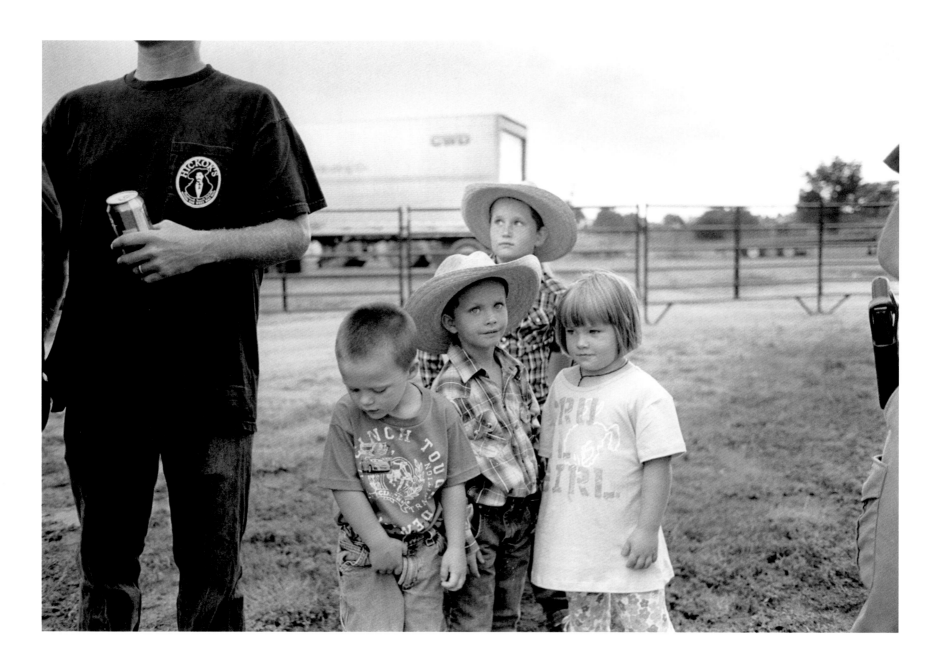

Ogallala, Nebraska 2011

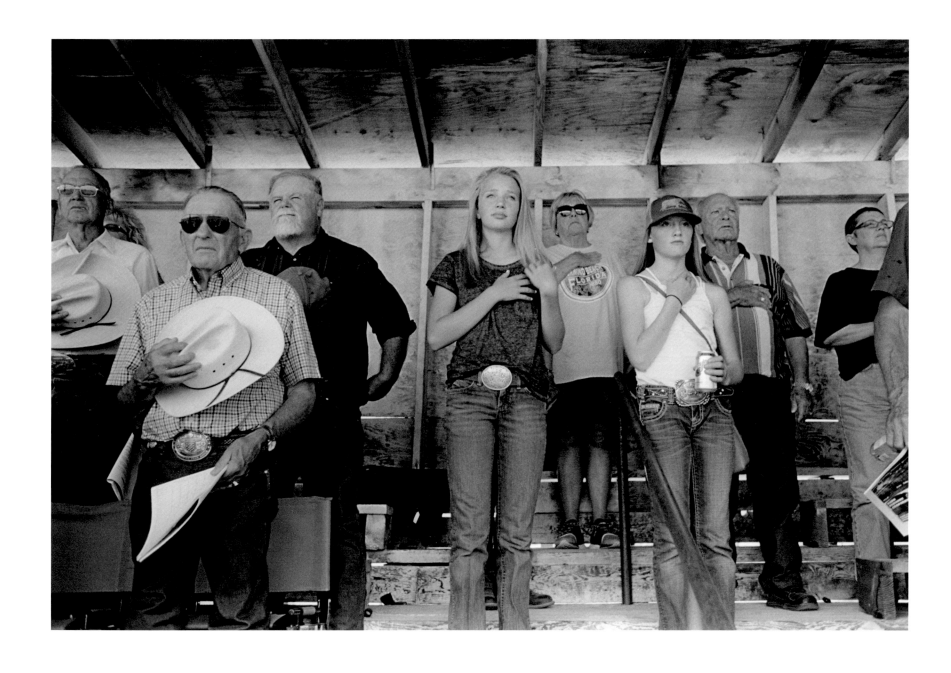

Wilsall, Montana 2018

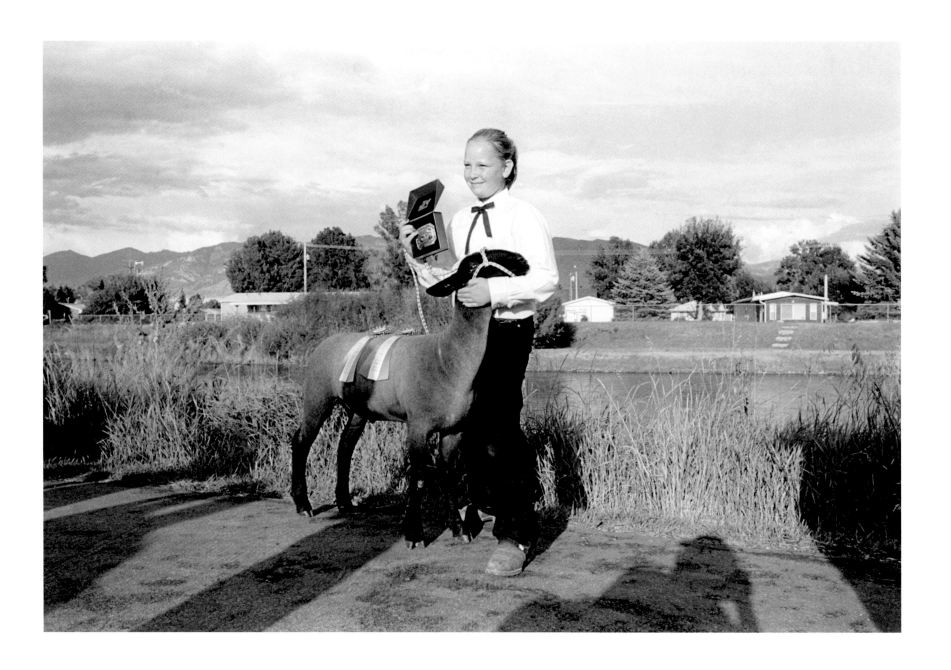

Twin Bridges, Montana 2014

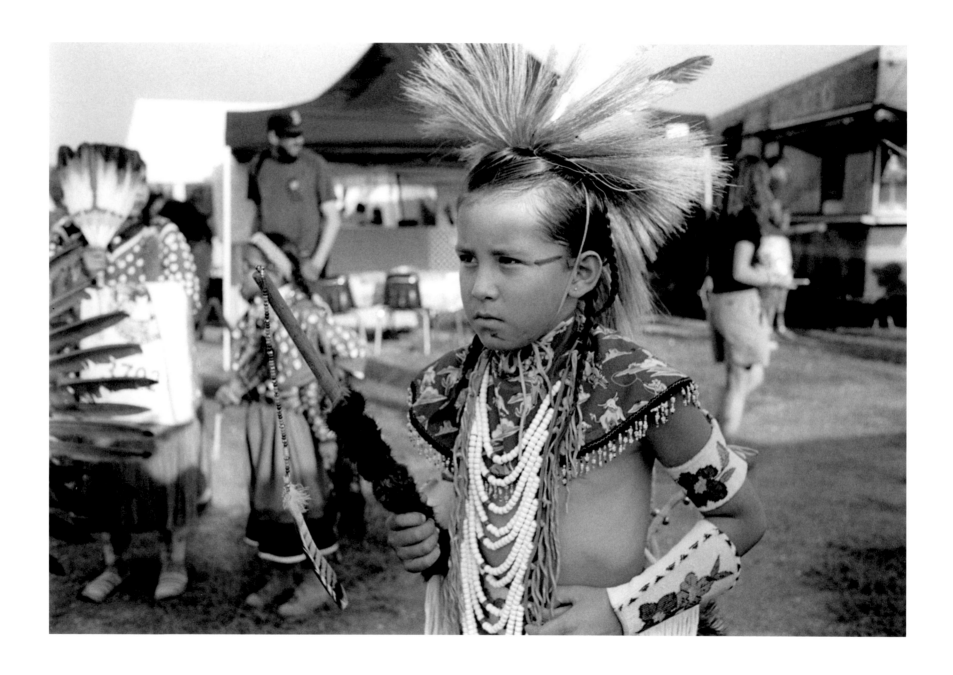

Crow Agency, Montana 2017

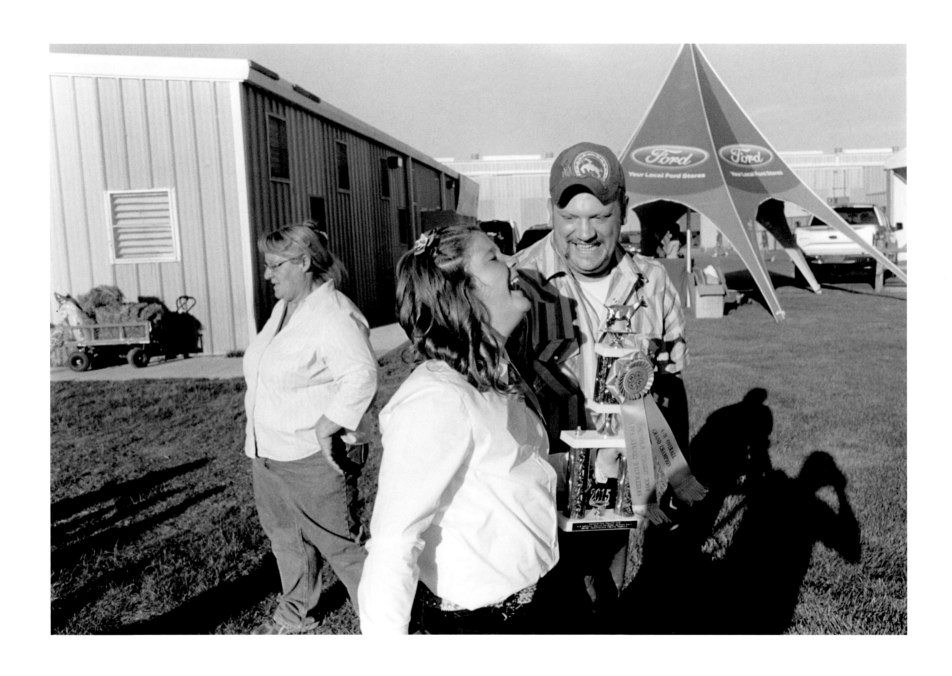

Rock Springs, Wyoming 2015

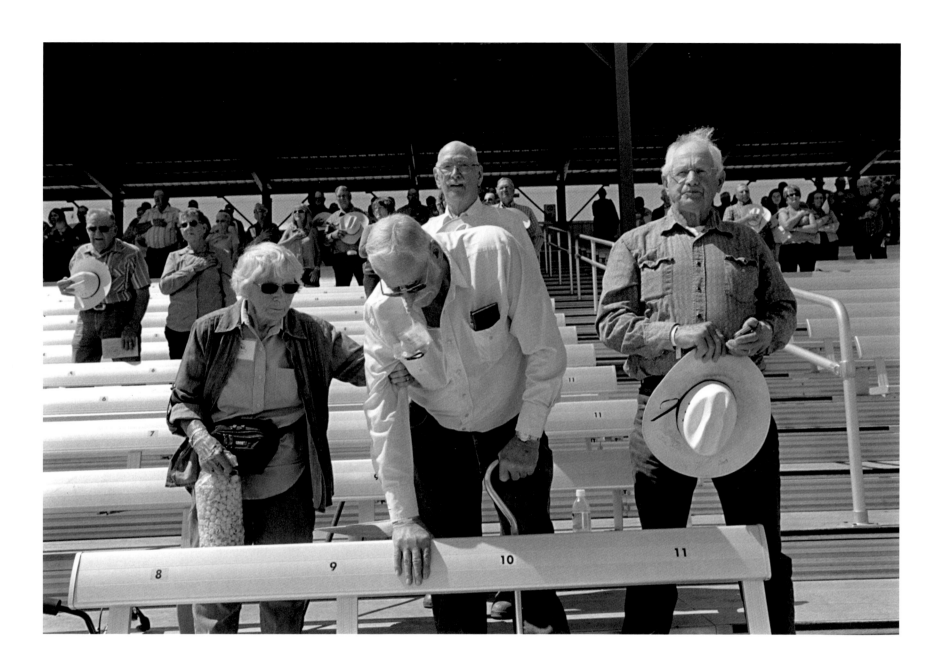

Glendive, Montana 2017

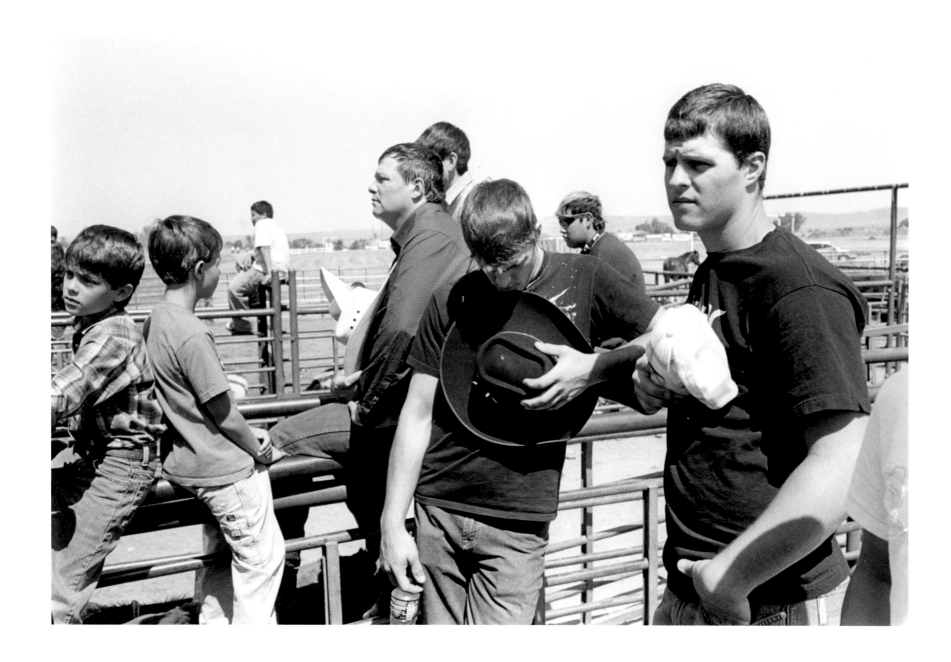

37

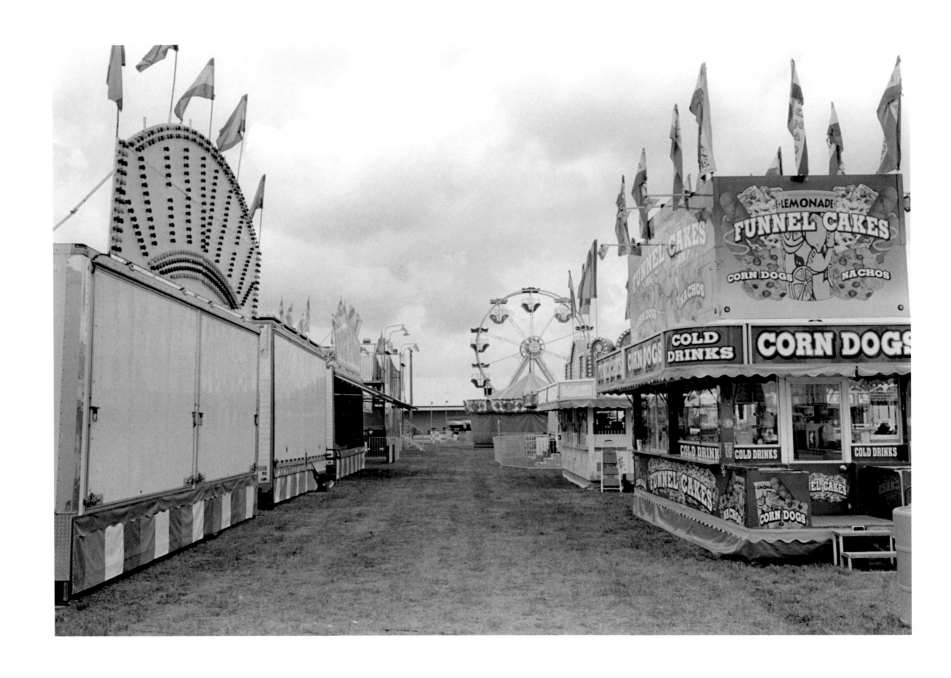

Aurora, Nebraska 2018

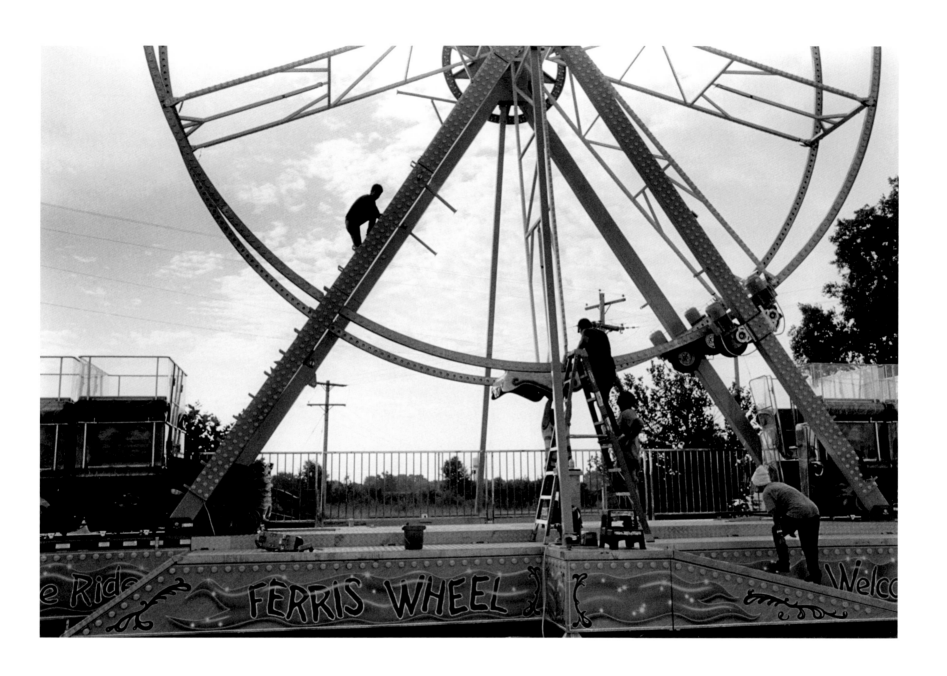

Central City, Nebraska 2018

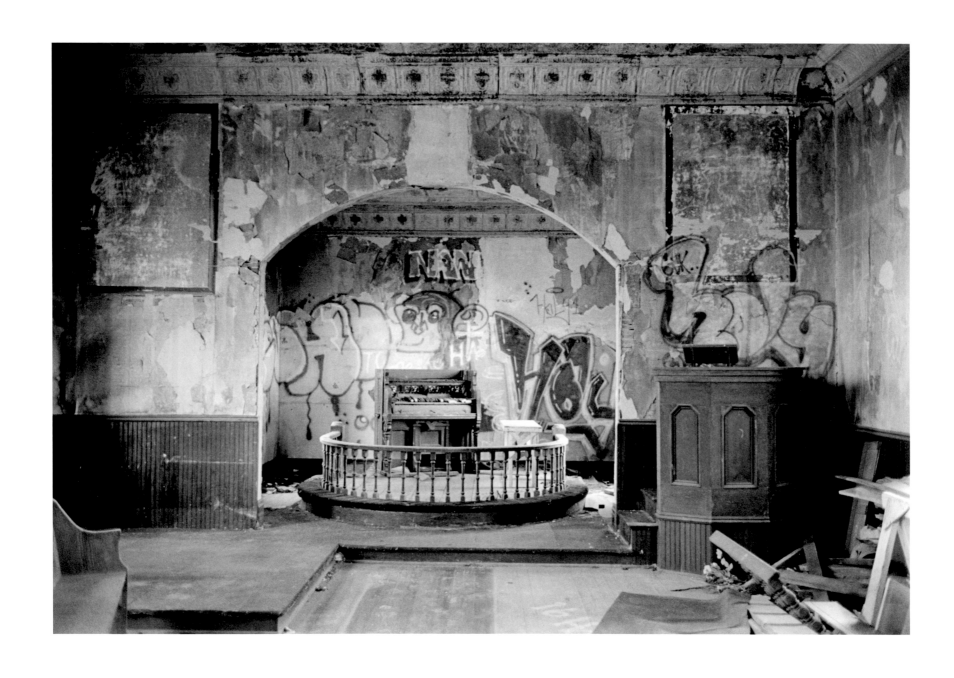

Seward, Nebraska 2011

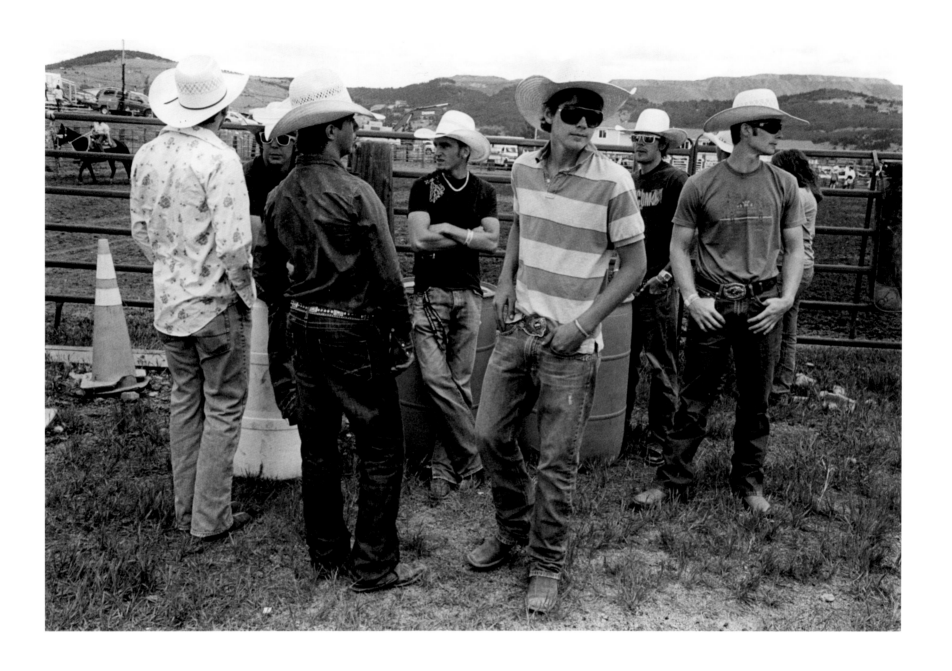

Cripple Creek, Colorado 2011

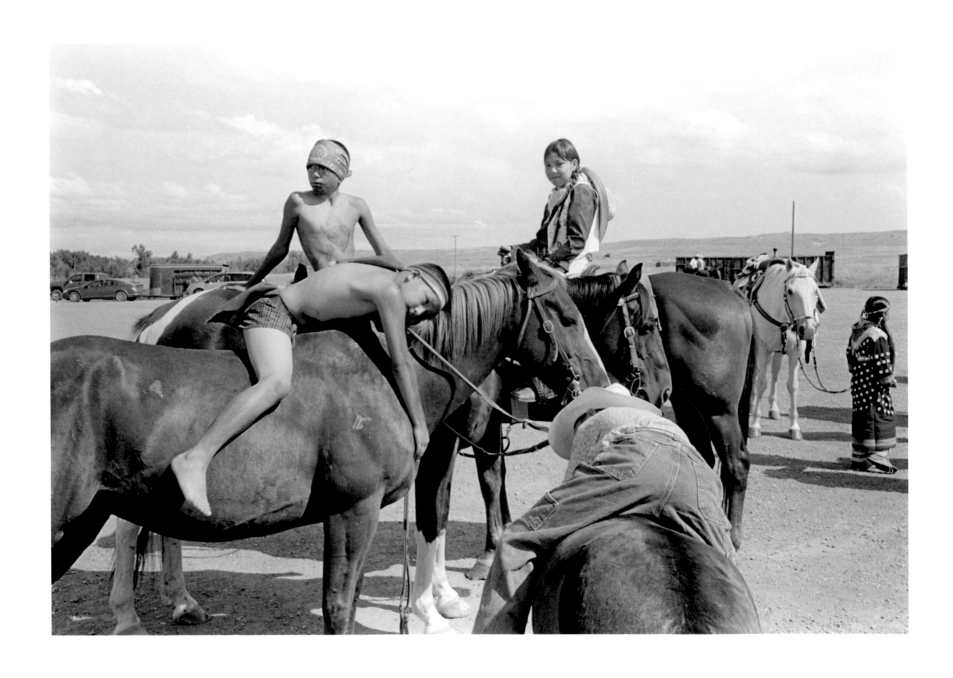

Crow Agency, Montana 2009

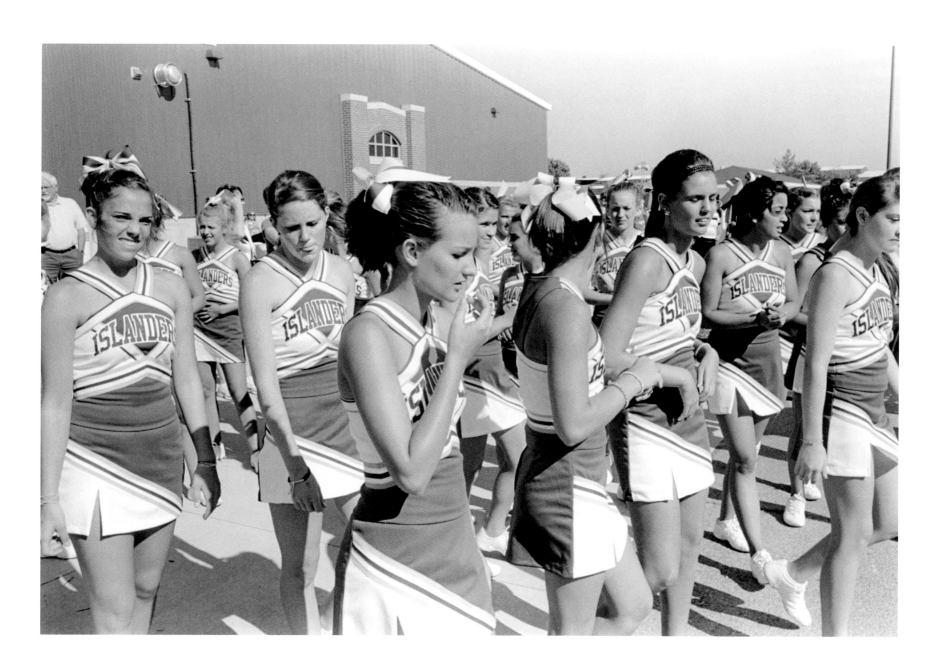

Grand Island, Nebraska 2010

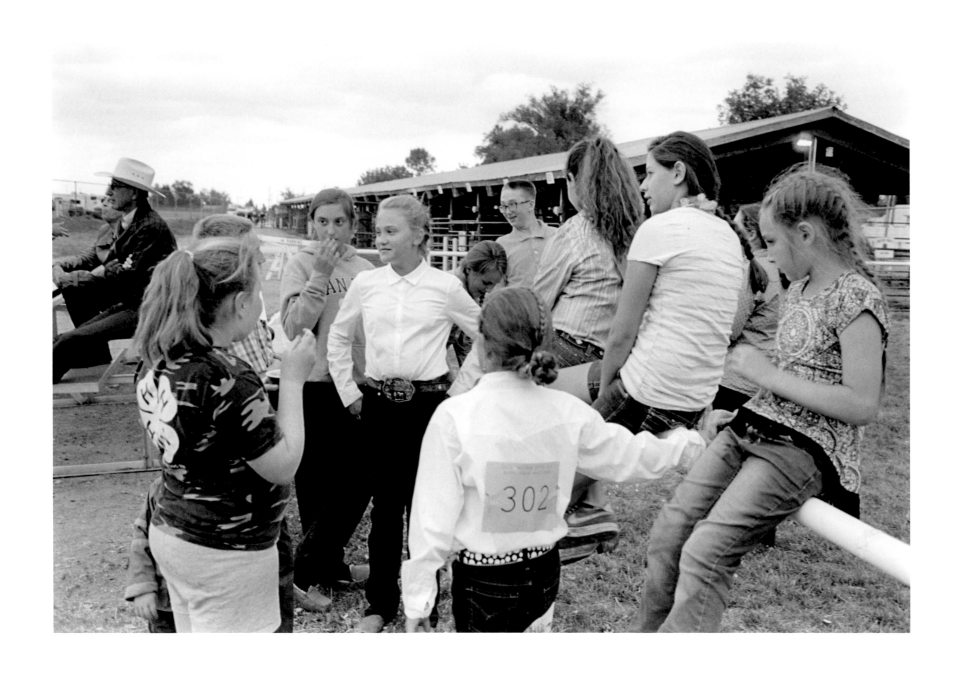

Sheridan, Wyoming 2017

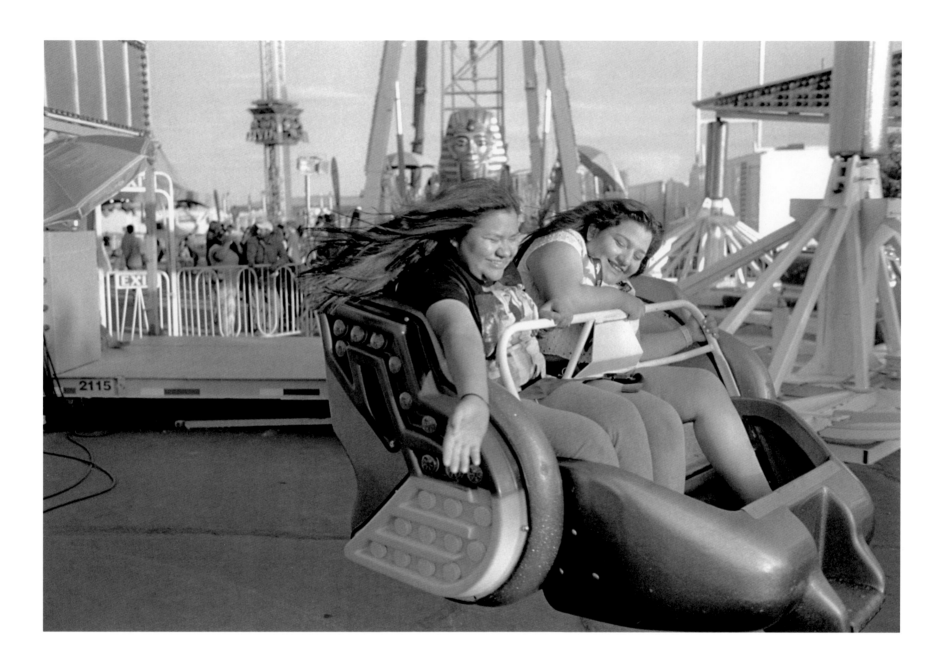

Rock Springs, Wyoming 2015

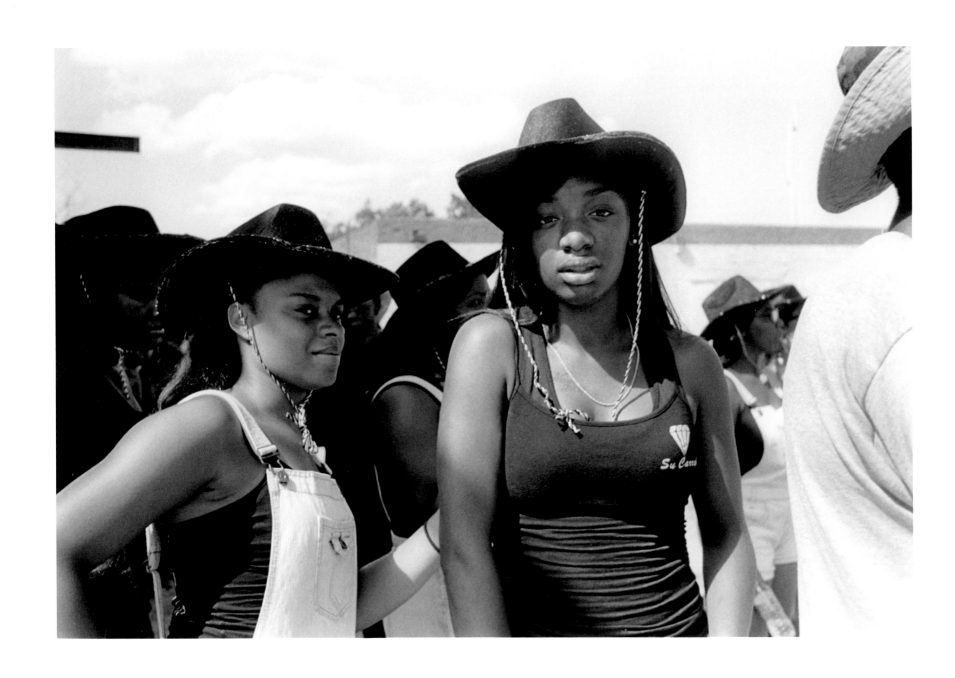

47

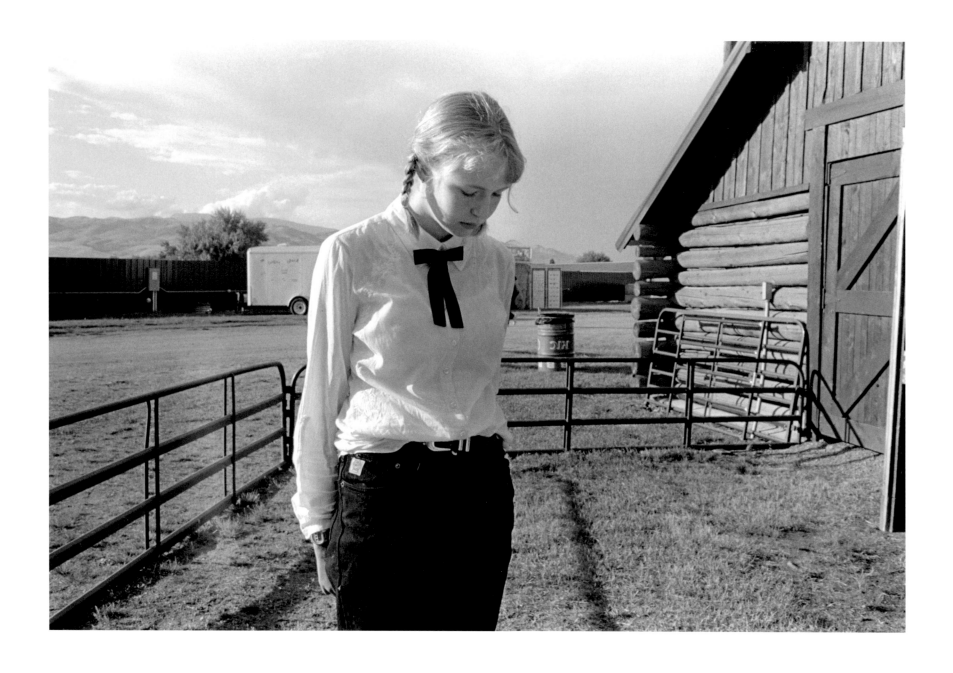

49

Twin Bridges, Montana 2014

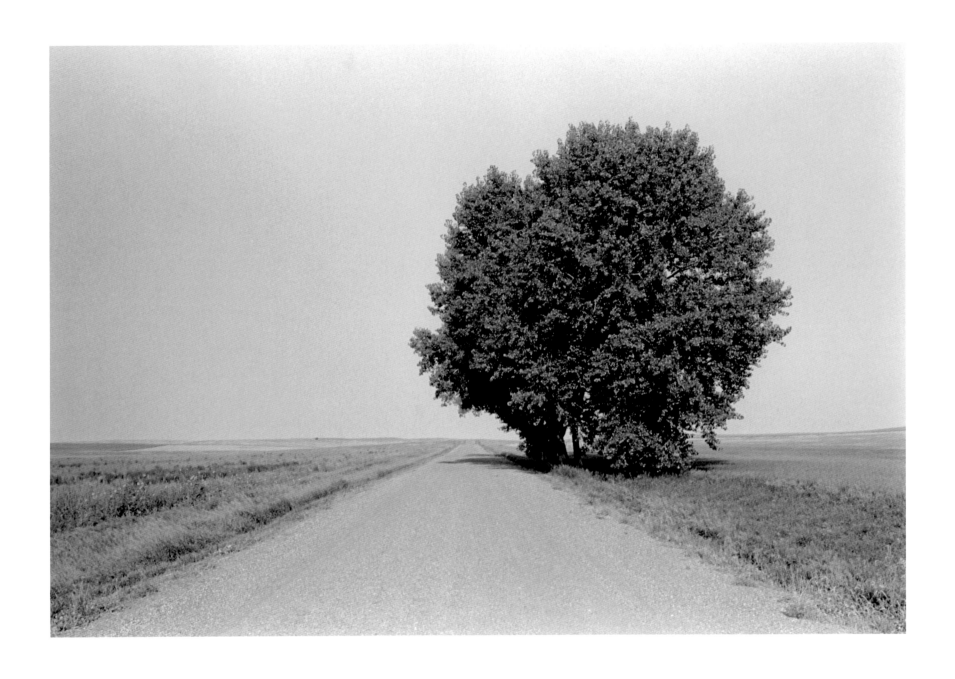

Northern North Dakota 2018

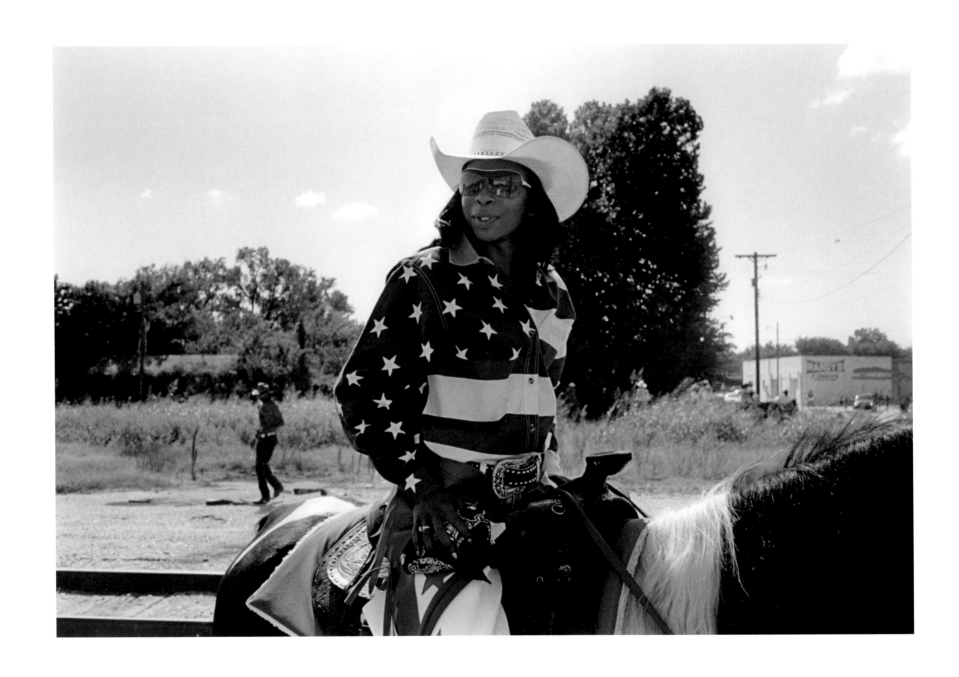

51

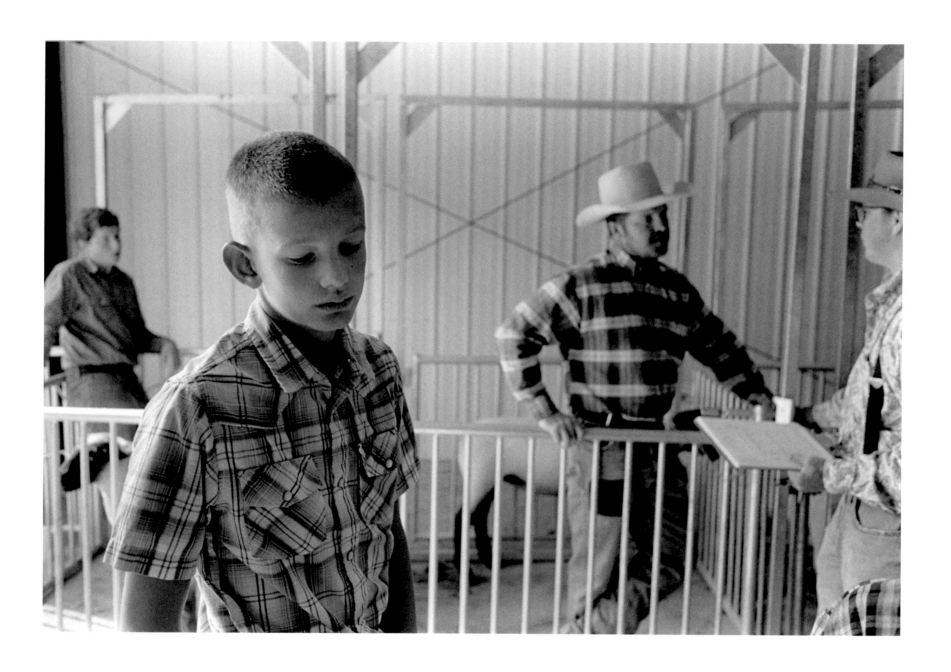

Basin, Wyoming 2017

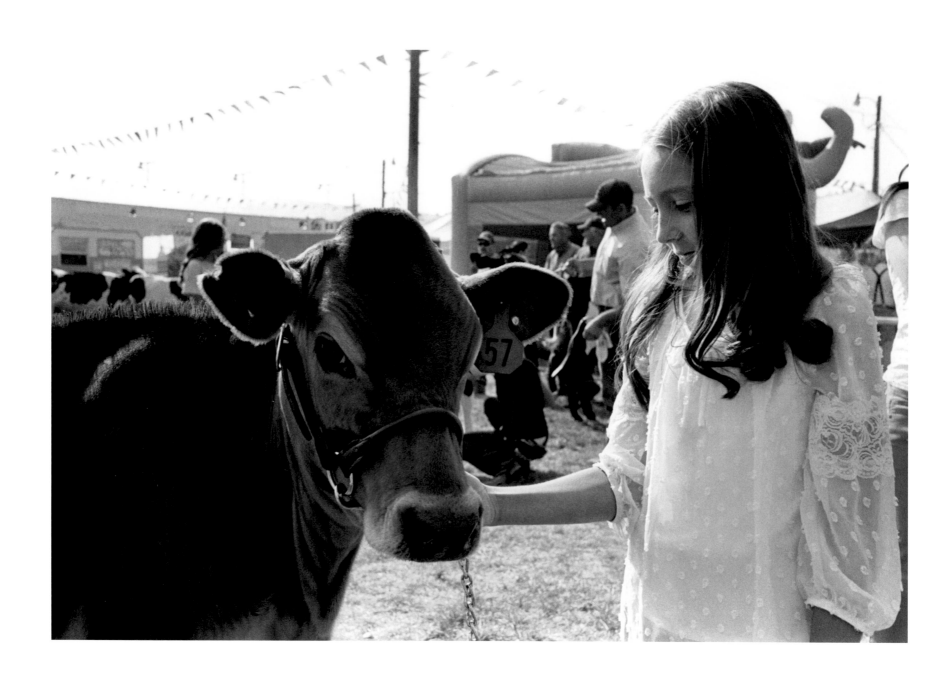

Burley, Idaho 2015

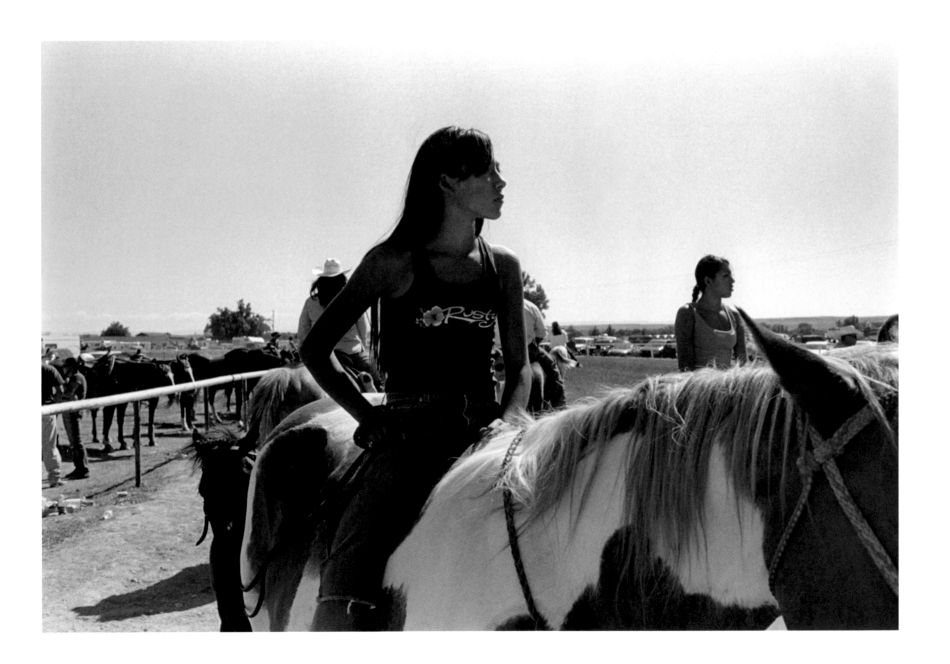

Crow Agency, Montana 2008

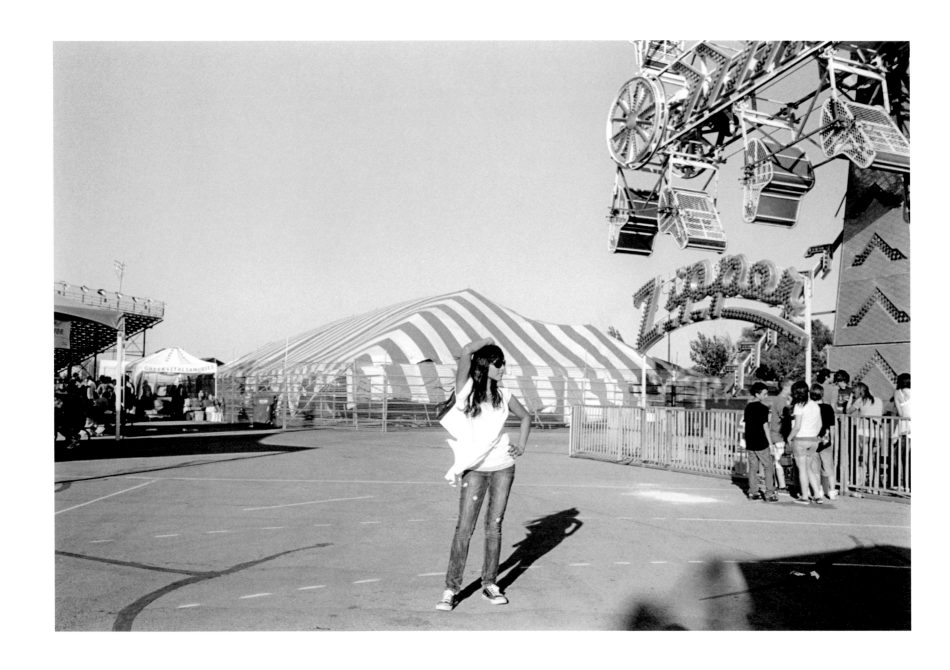

55

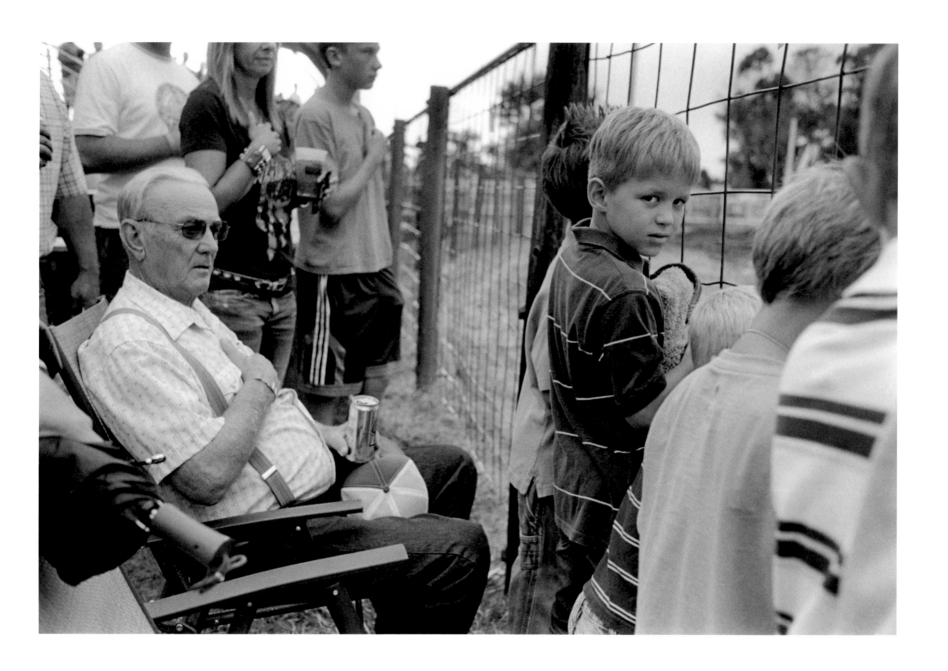

Ogallala, Nebraska 2011

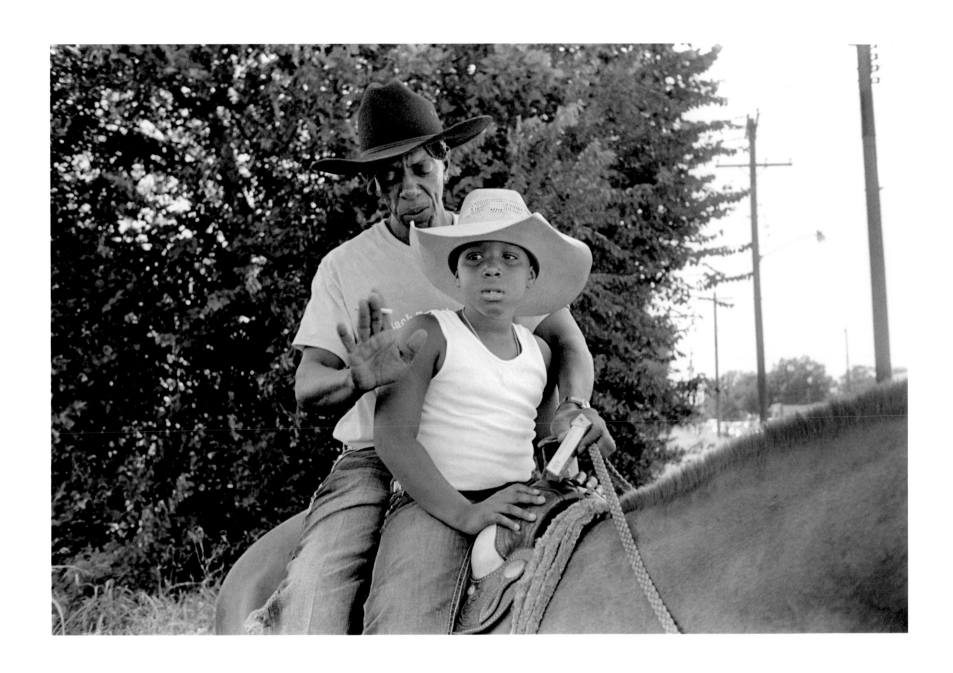

Okmulgee, Oklahoma 2015

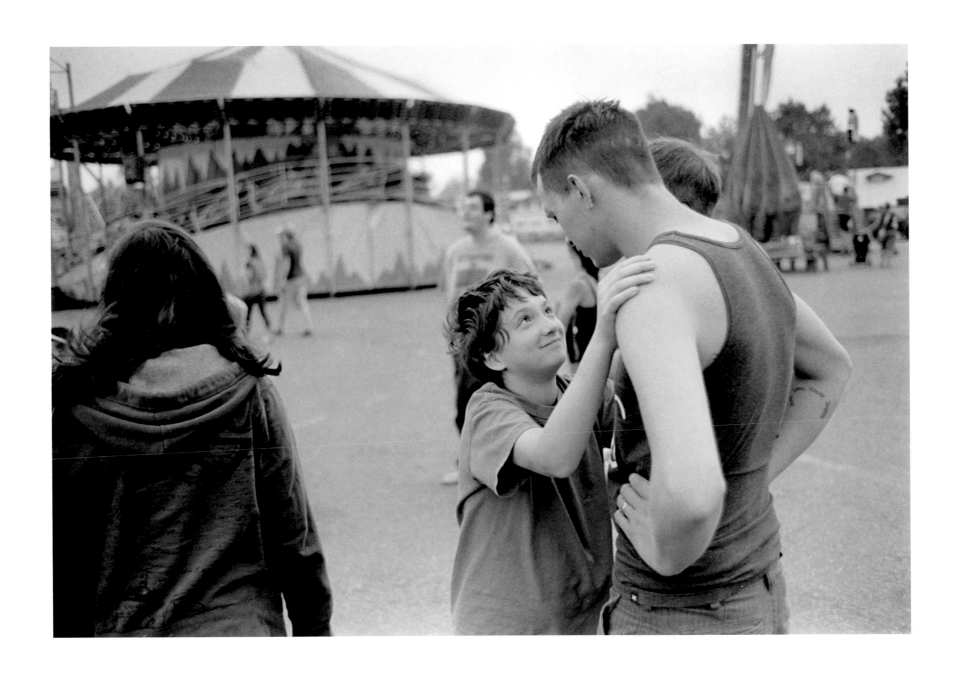

59

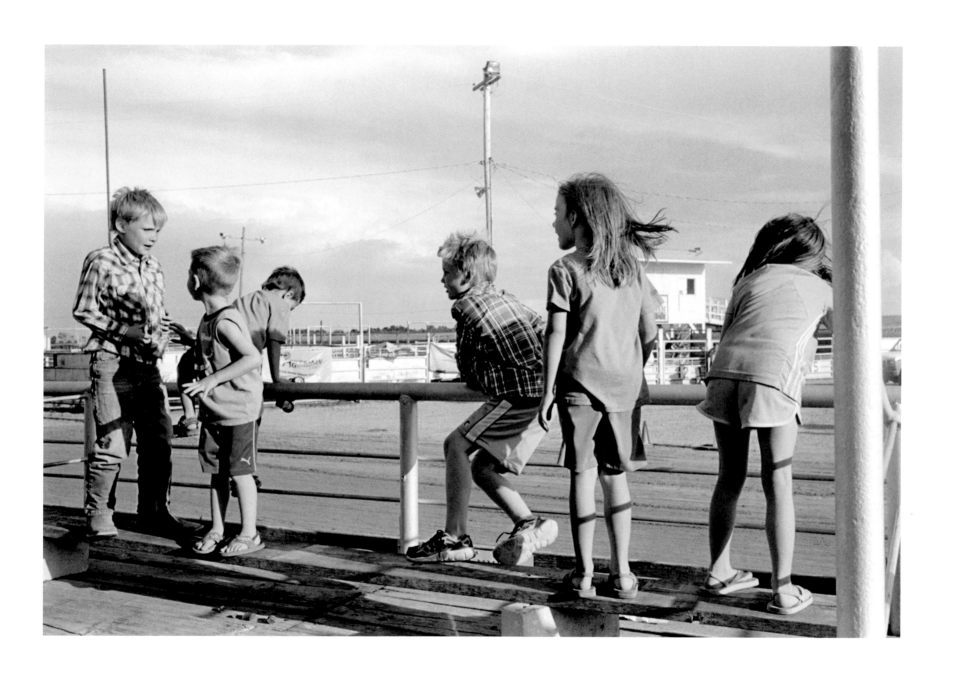

Bridgeport, Nebraska 2015

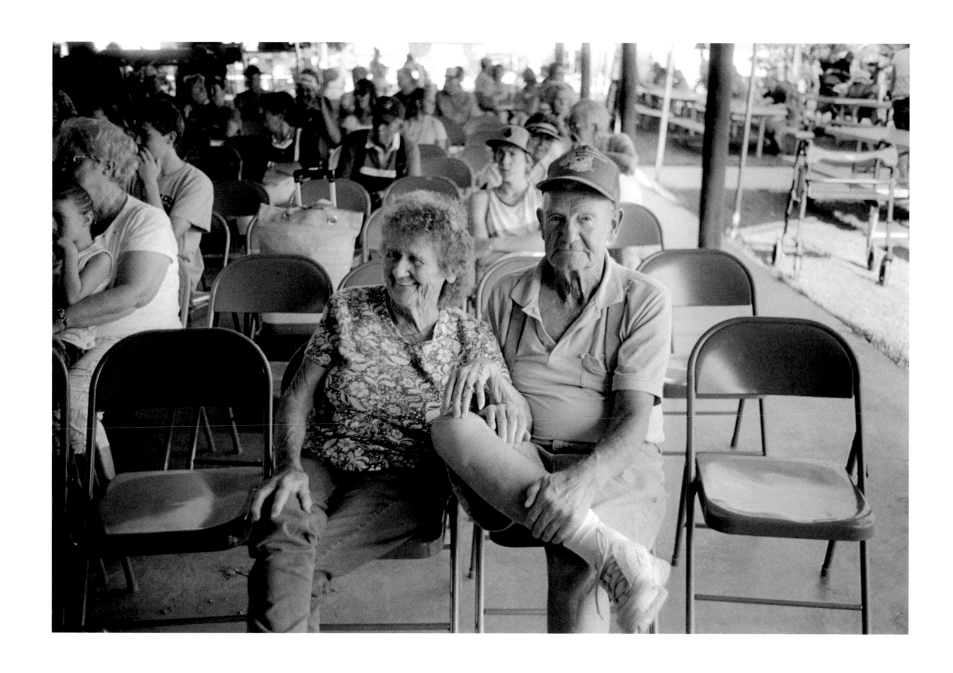

Castle Dale, Utah 2013

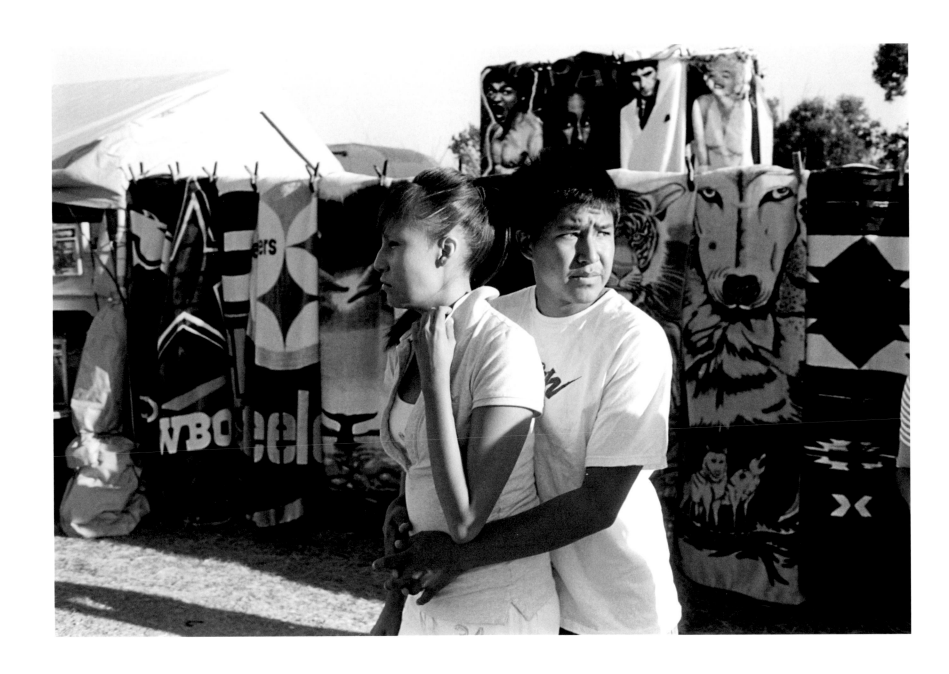

Crow Agency, Montana 2008

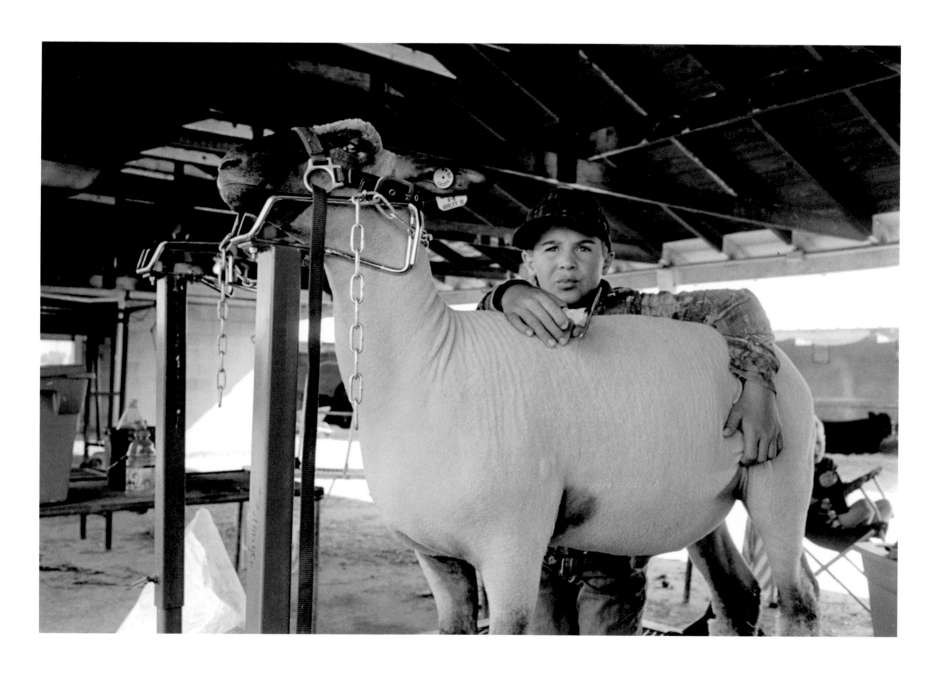

Burley, Idaho 2015

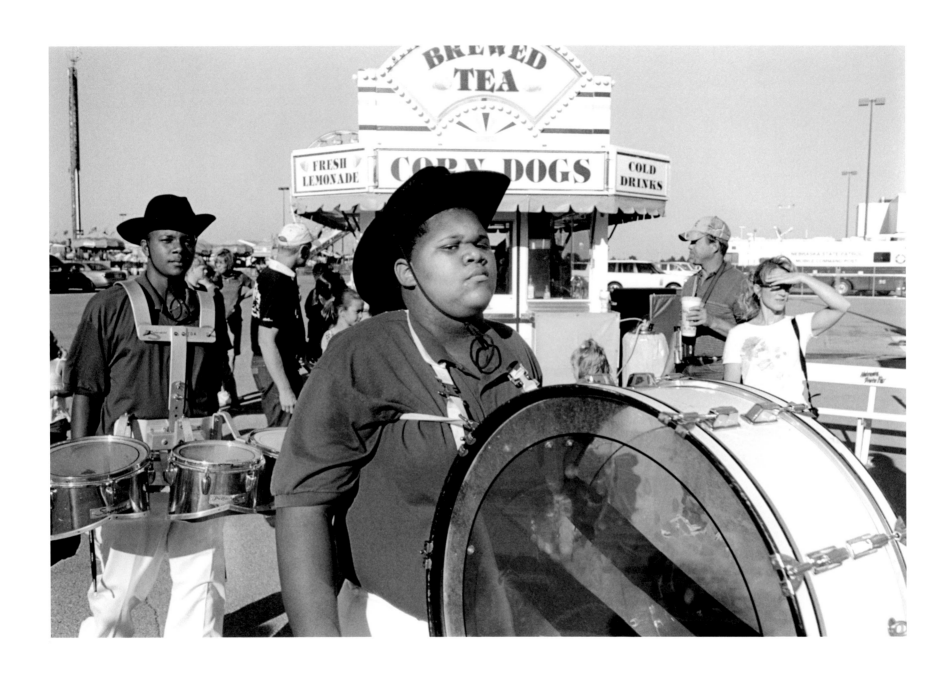

Grand Island, Nebraska 2010

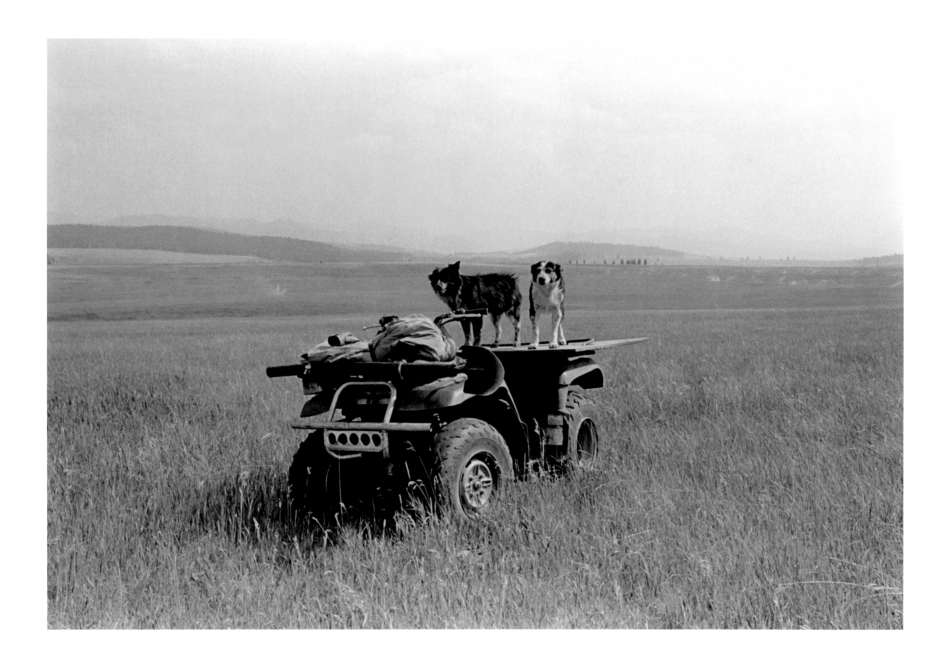

Western Montana 2014

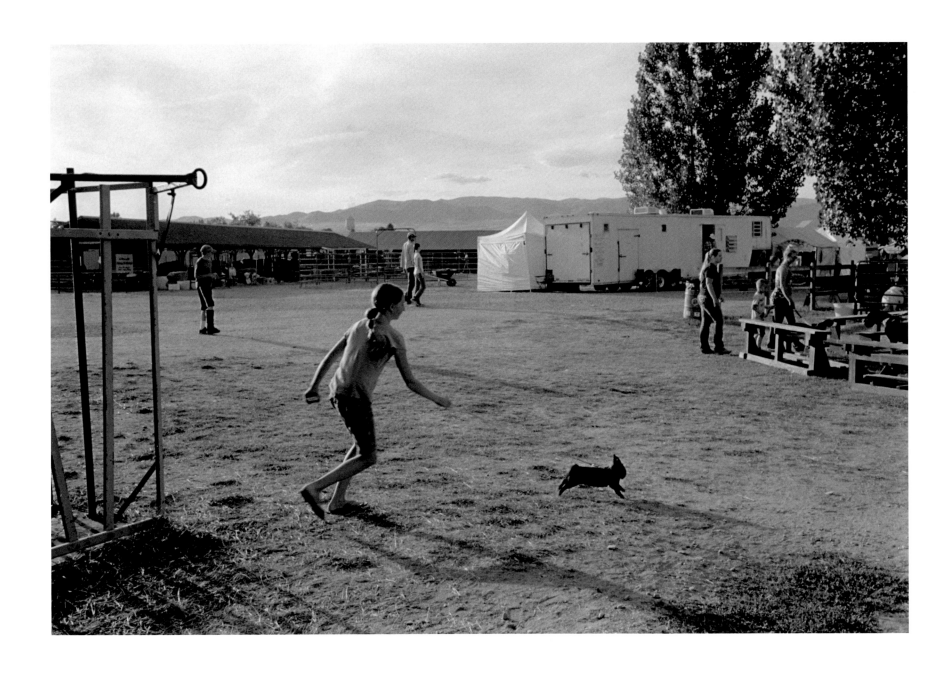

Twin Bridges, Montana 2016

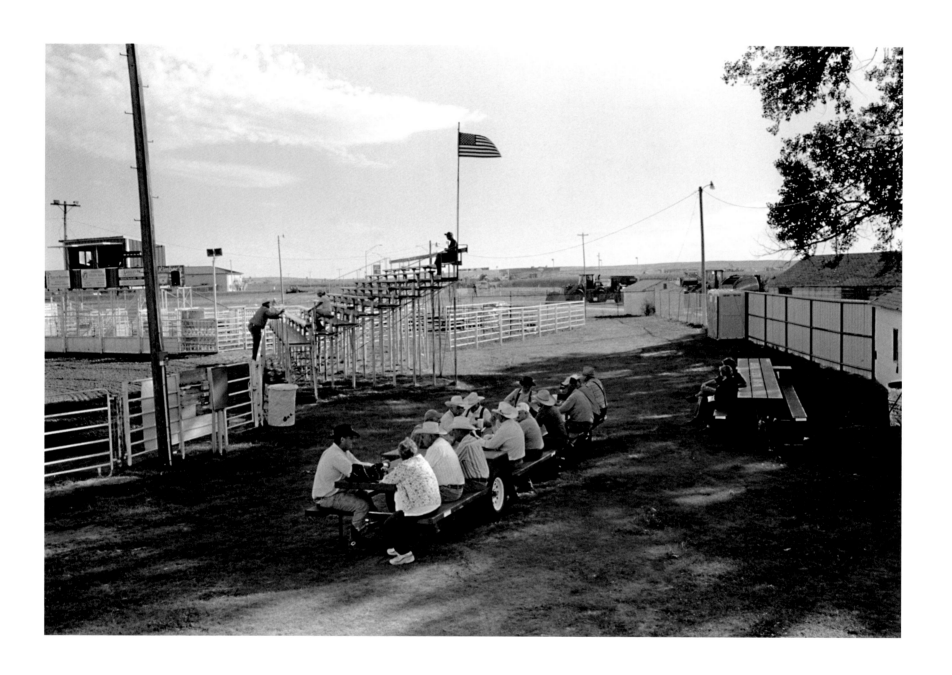

Stapleton, Nebraska 2014

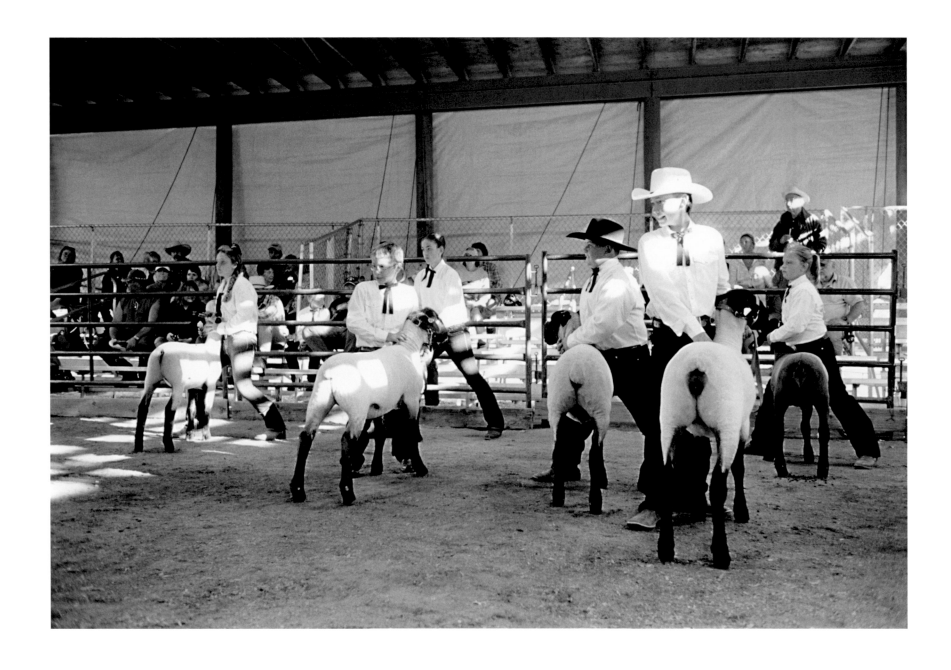

Twin Bridges, Montana 2014

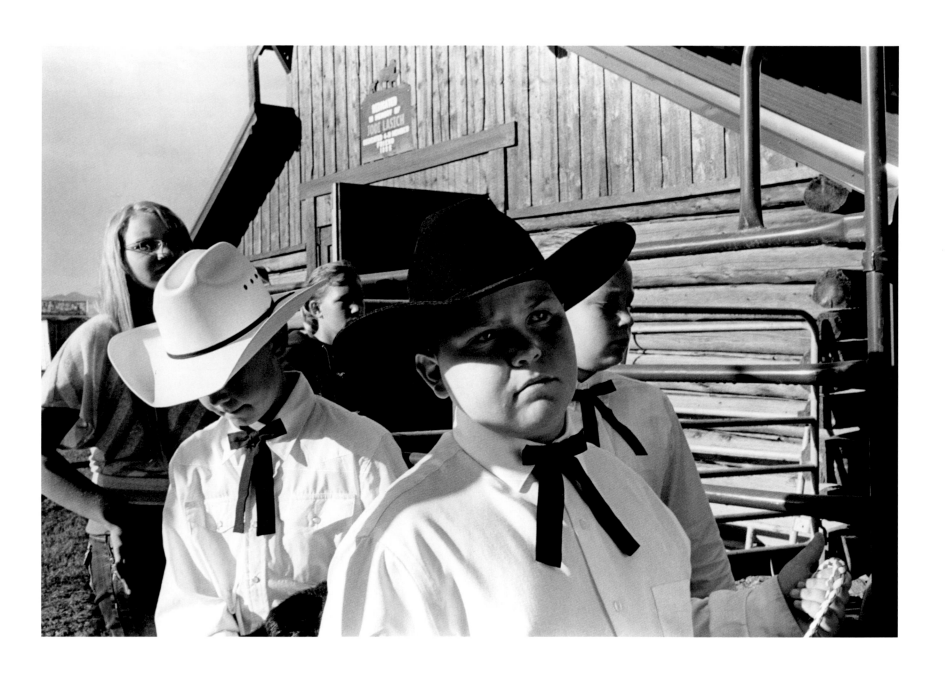

Twin Bridges, Montana 2014

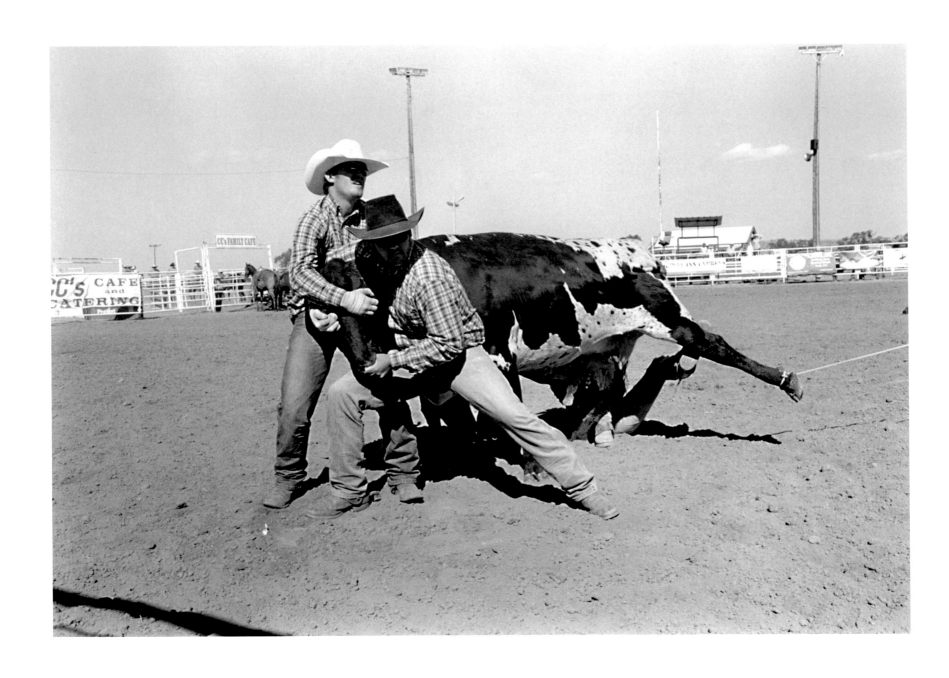

71

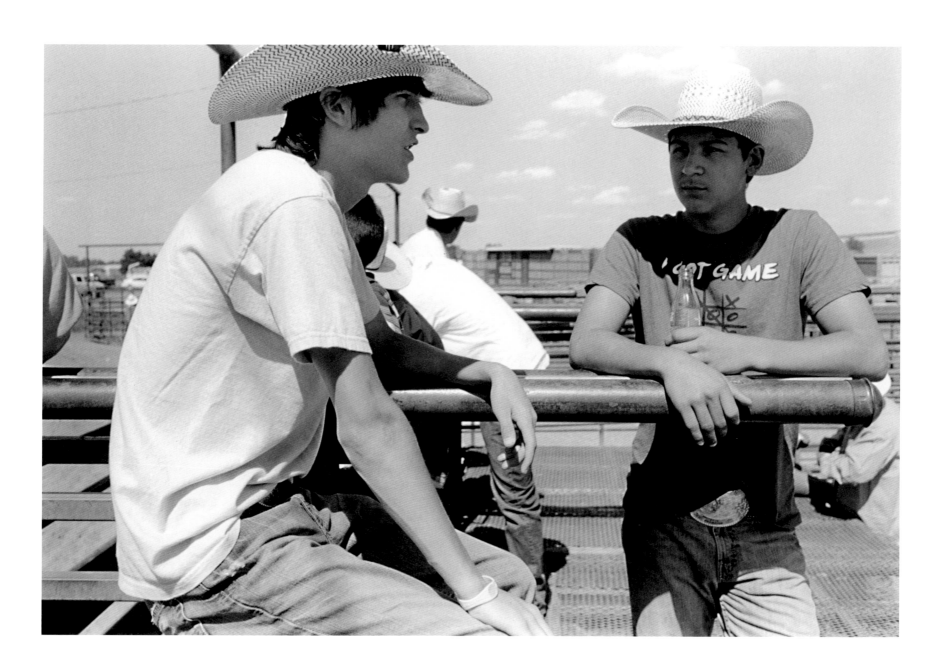

Crow Agency, Montana 2011

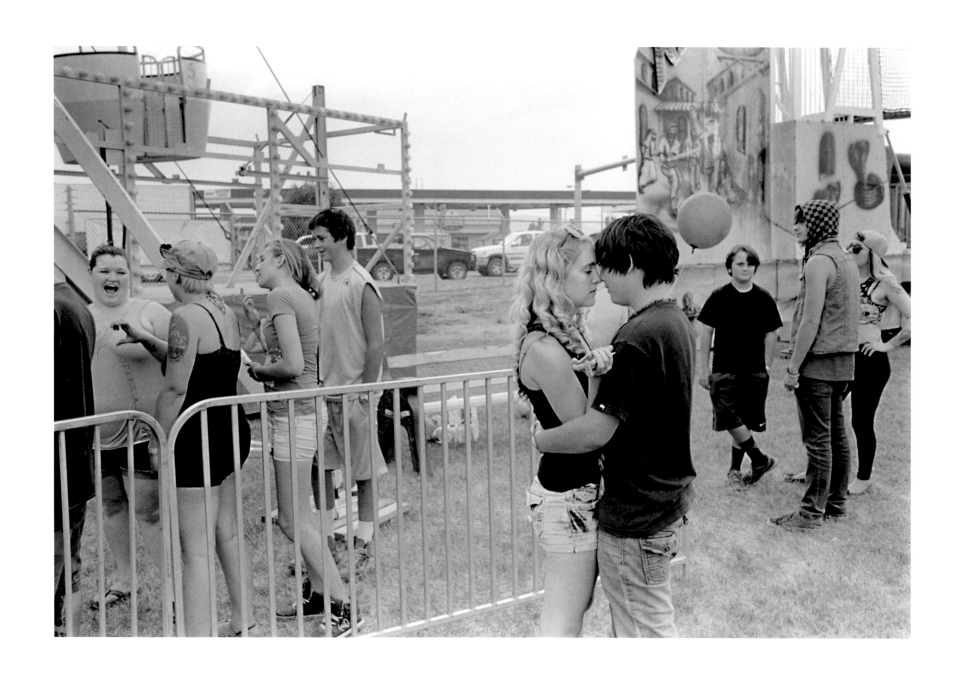

73

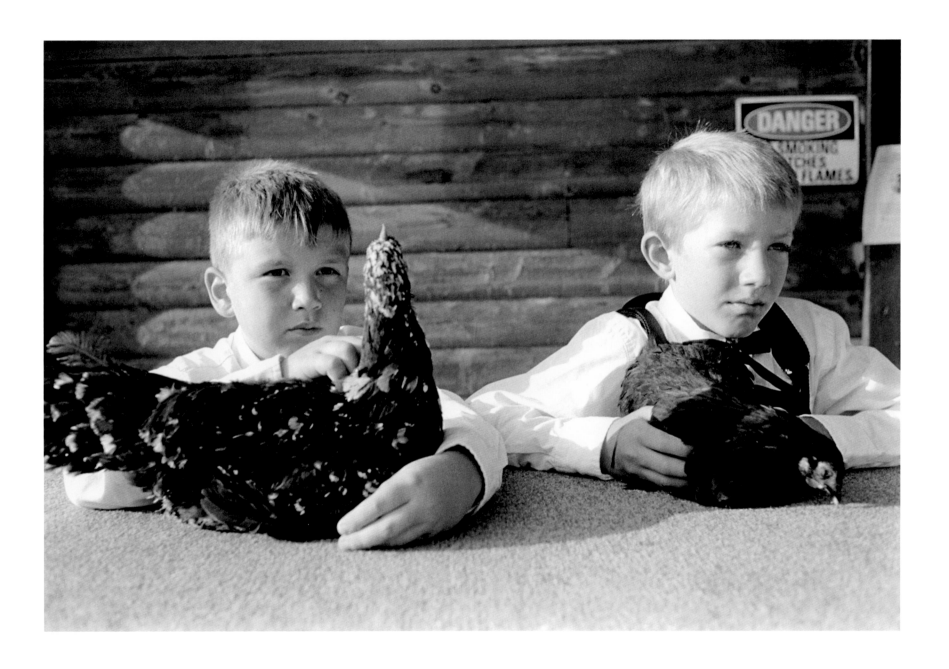

Twin Bridges, Montana 2018

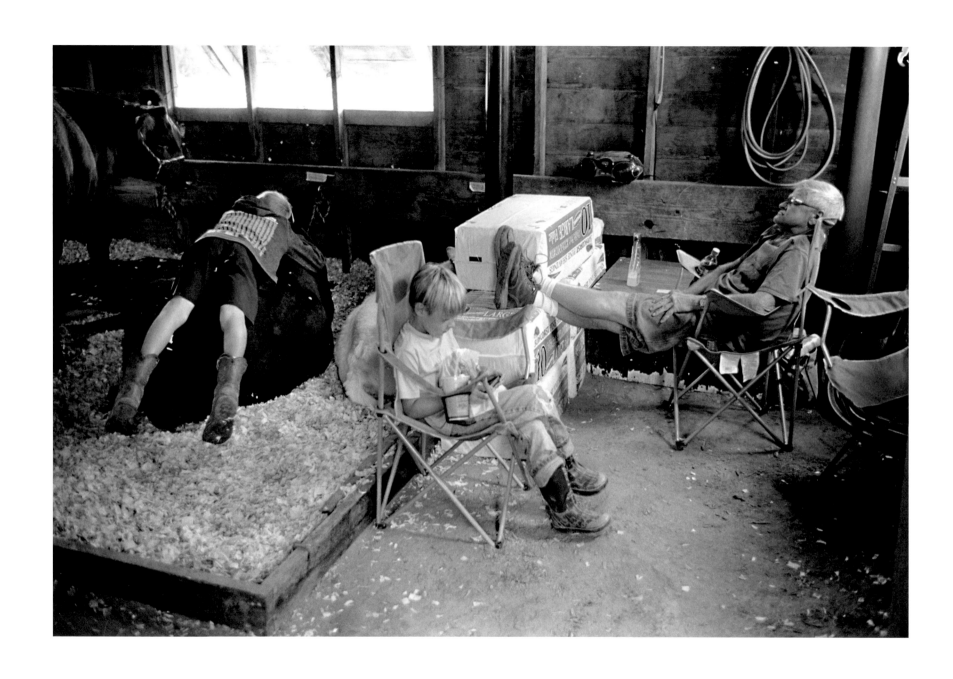

Broken Bow, Nebraska 2018

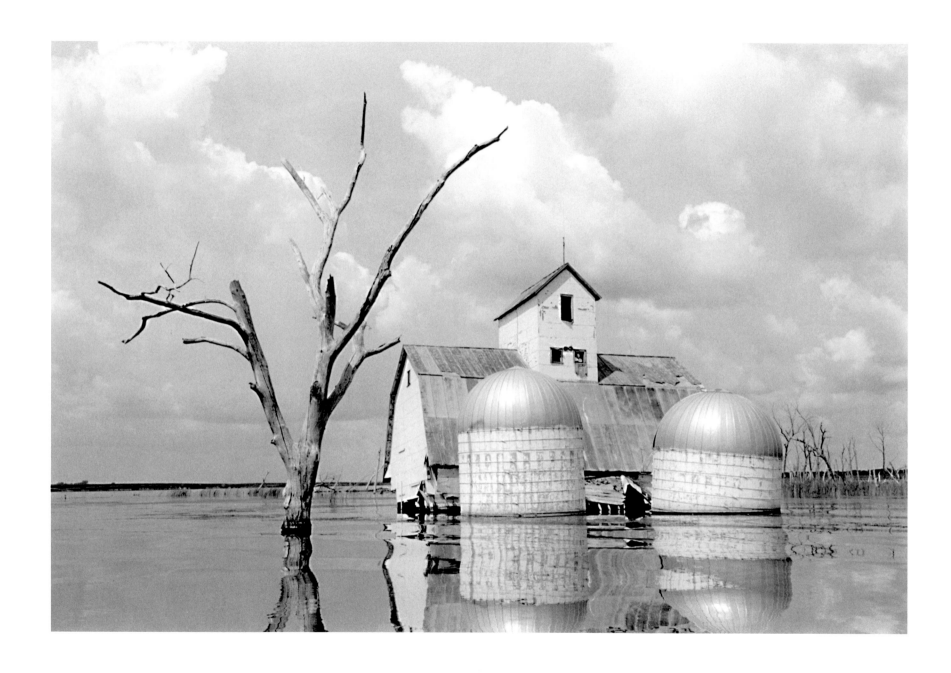

Day County, South Dakota 2014

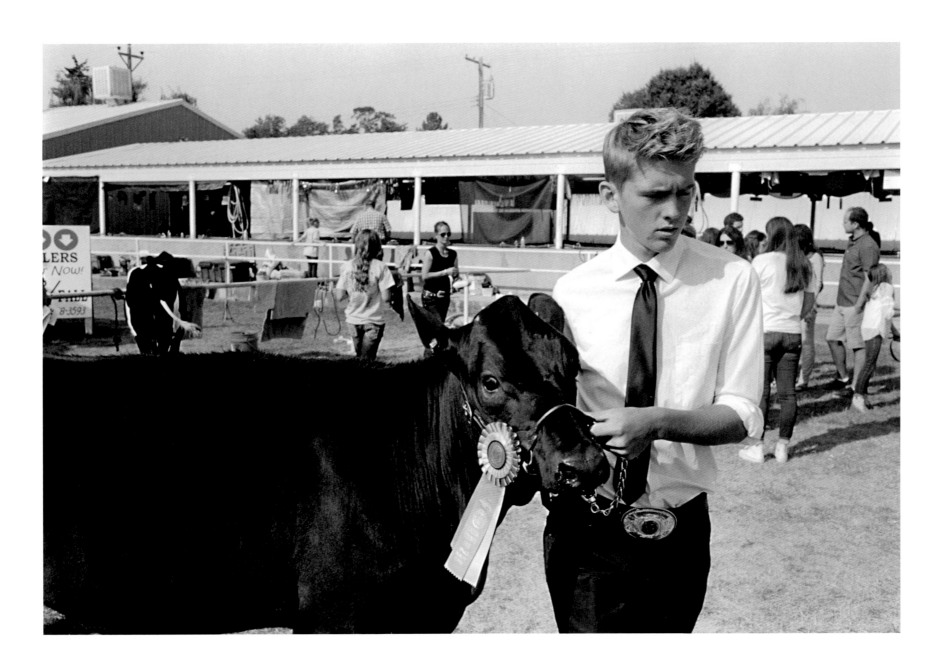

Burley, Idaho 2015

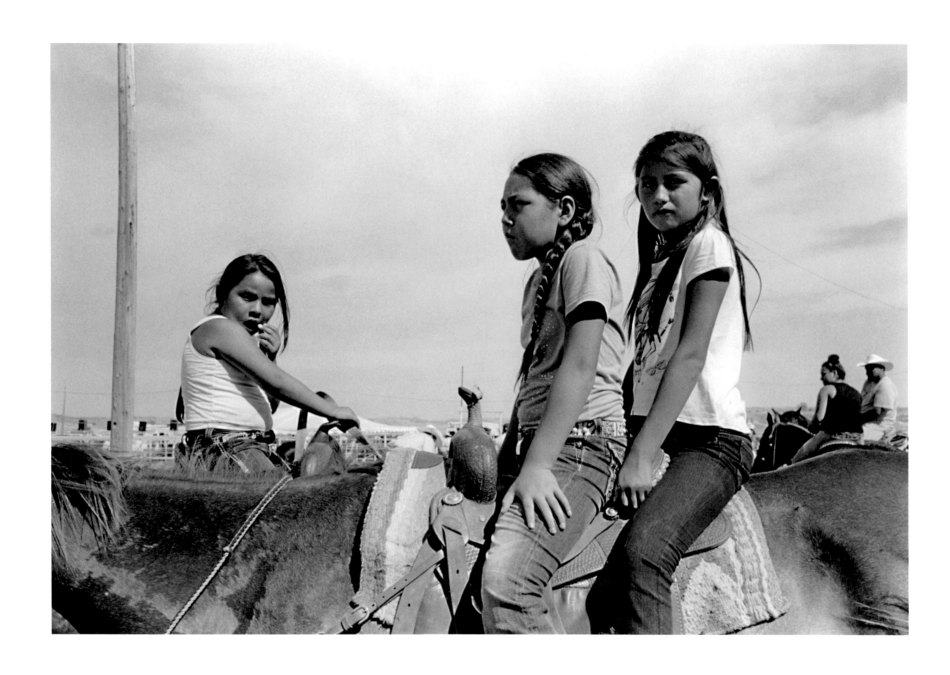

Crow Agency, Montana 2014

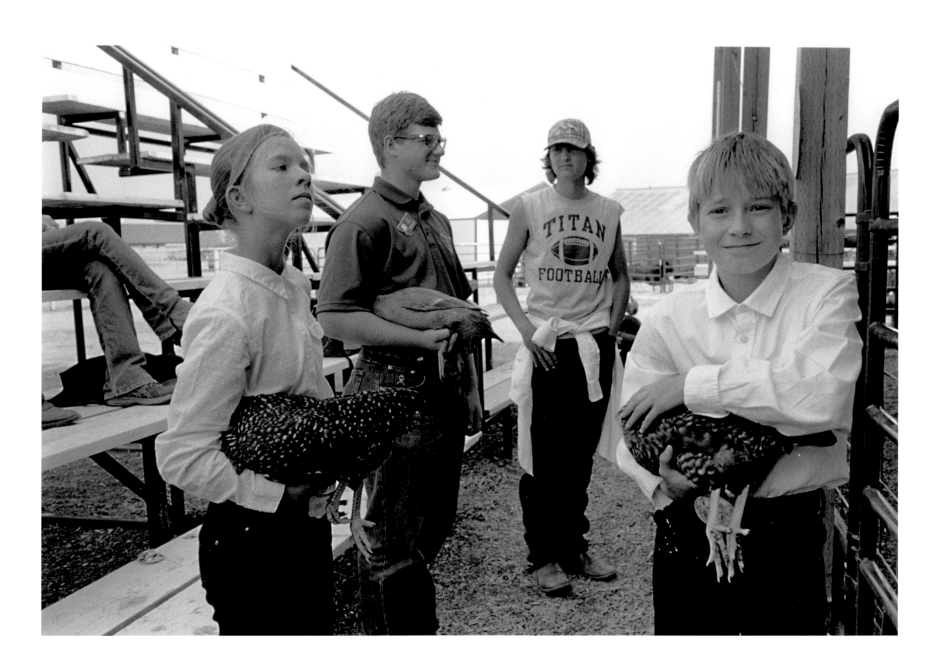

Stanford, Montana 2017

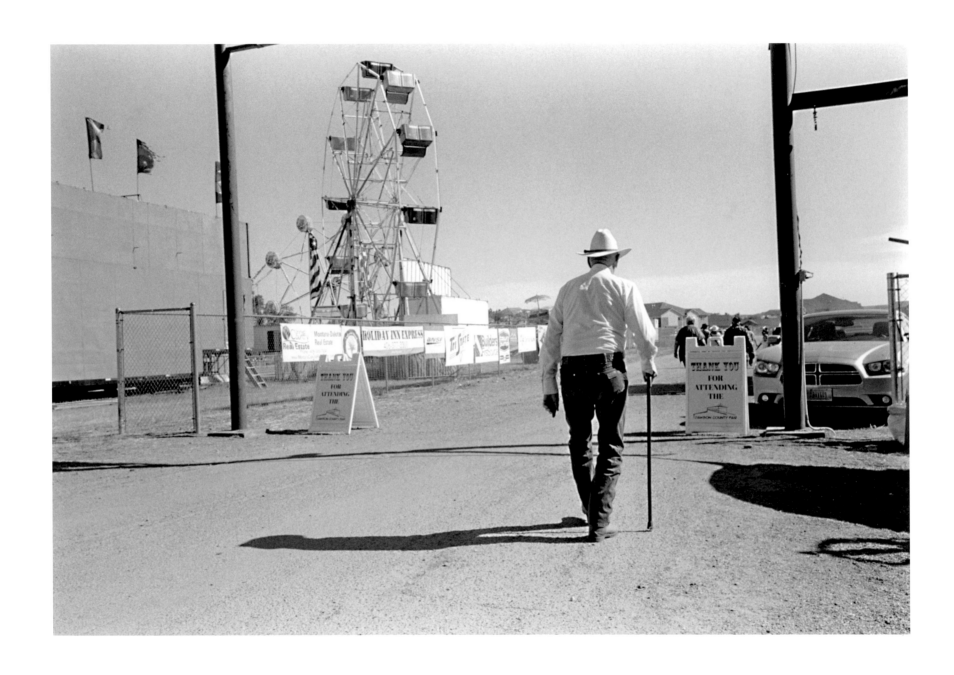

Glendive, Montana 2017

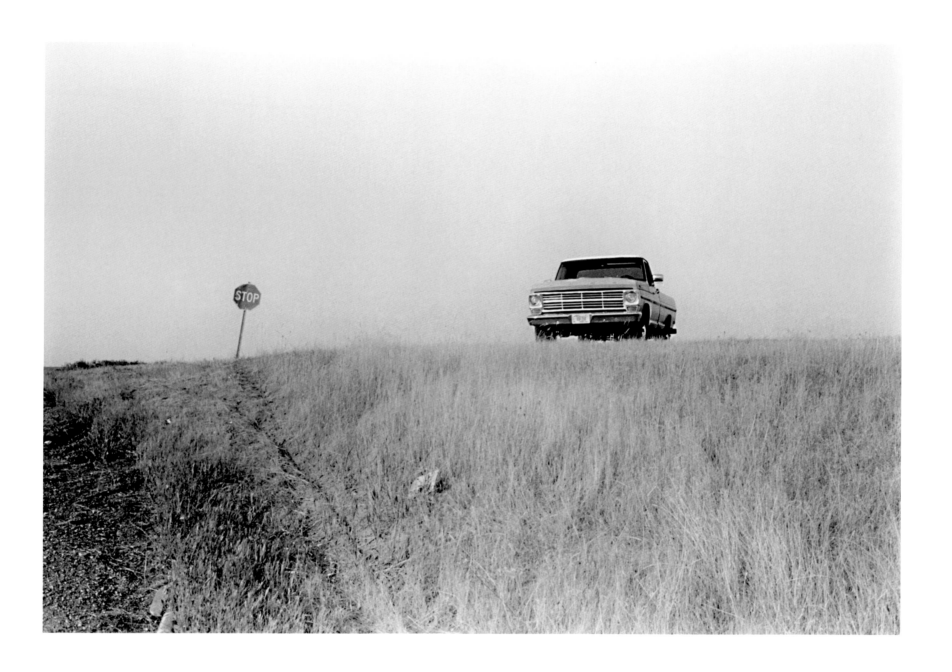

Crow Agency, Montana 2017

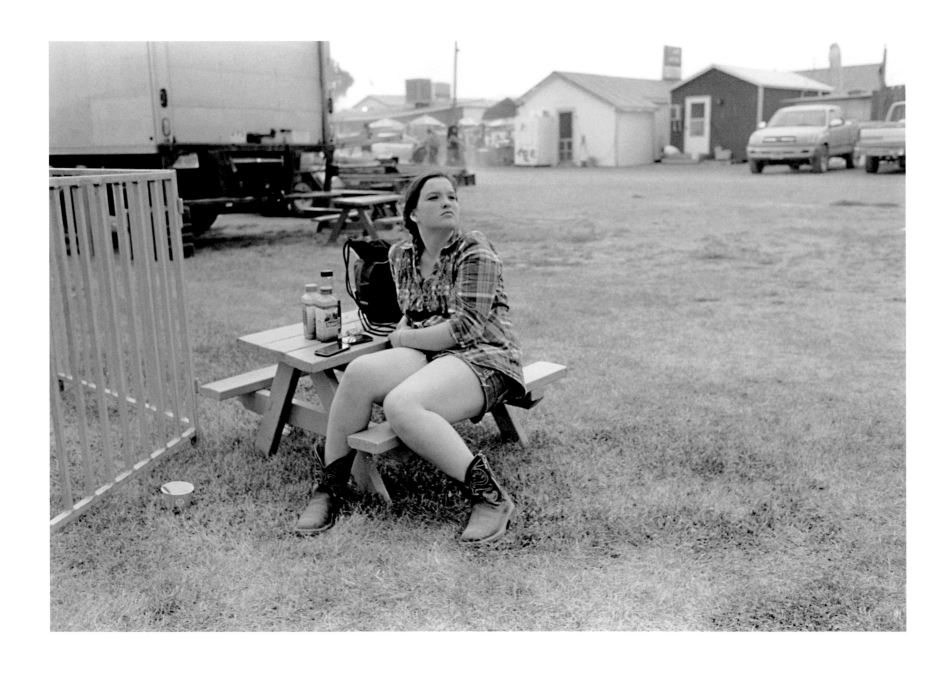

83

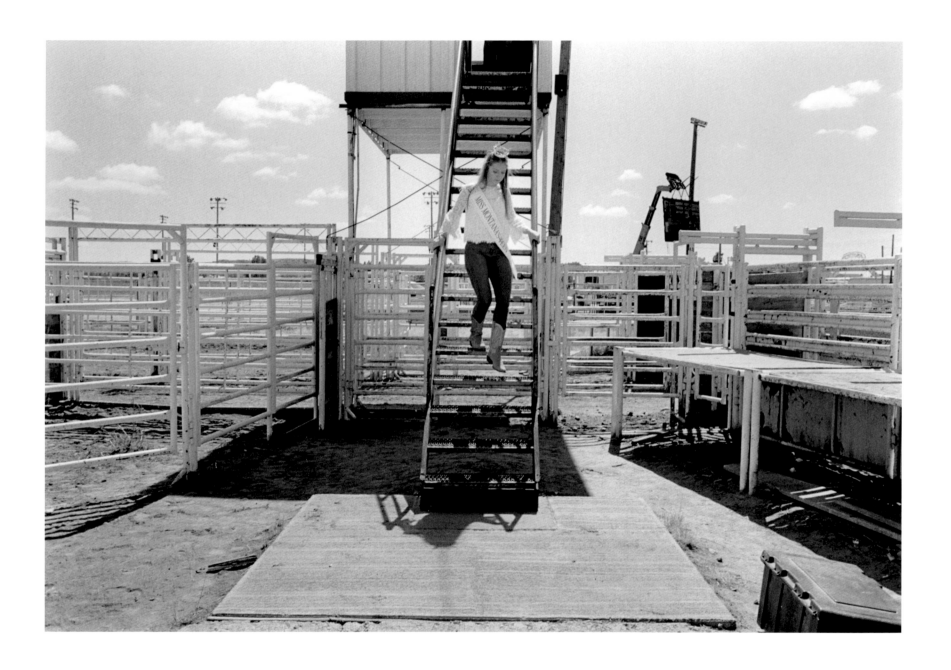

Glendive, Montana 2017

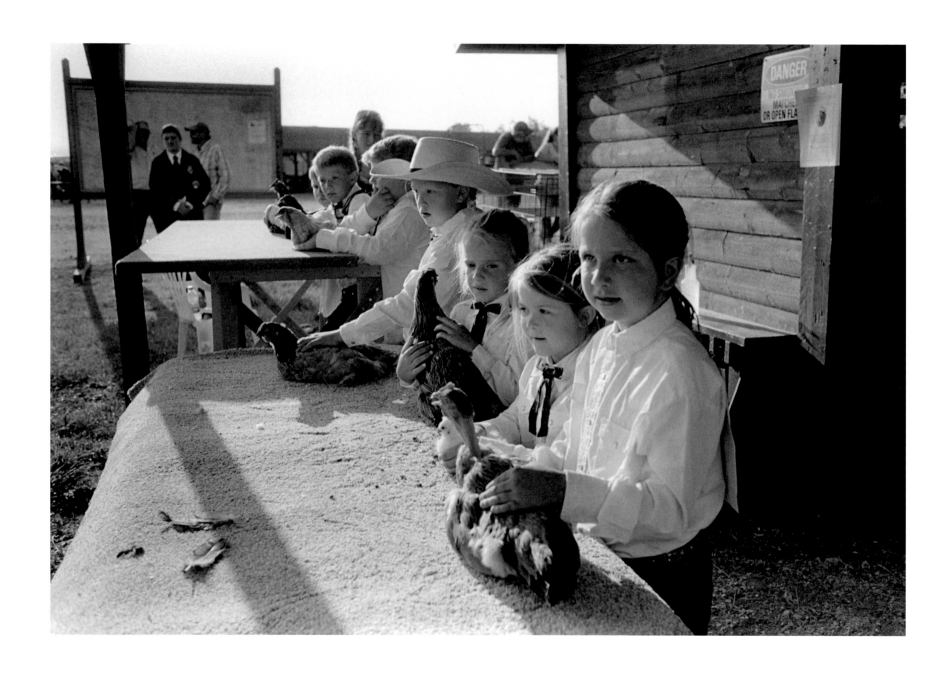

Twin Bridges, Montana 2018

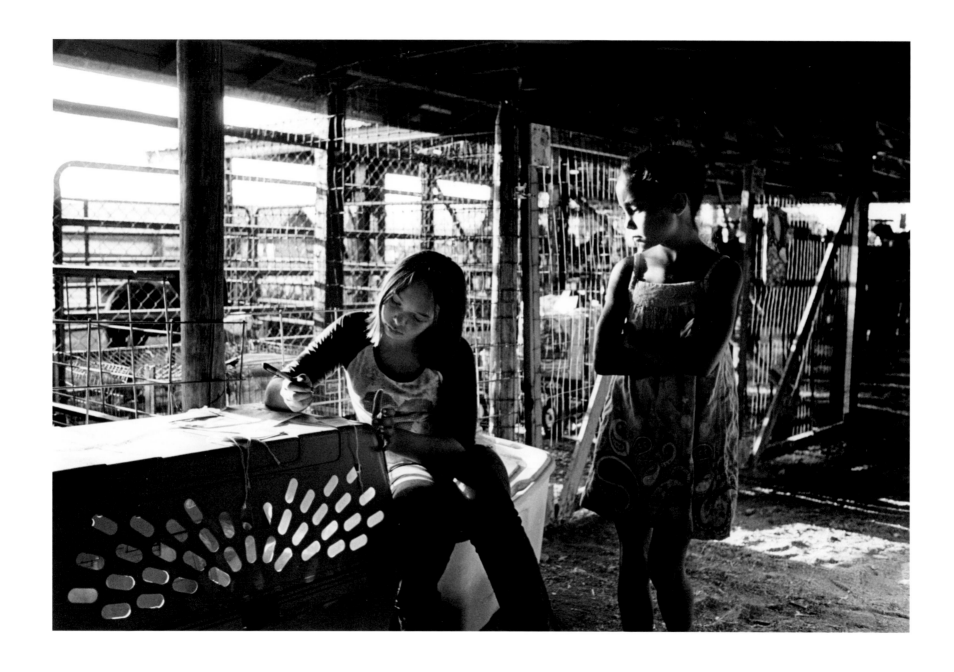

87 Twin Bridges, Montana 2014

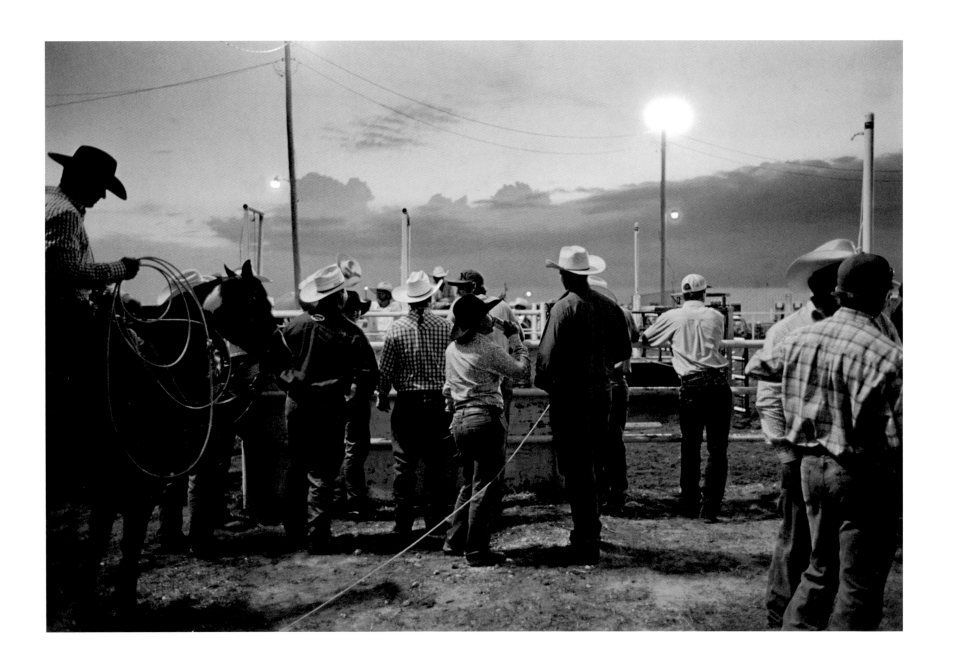

Waynoka, Oklahoma 2013

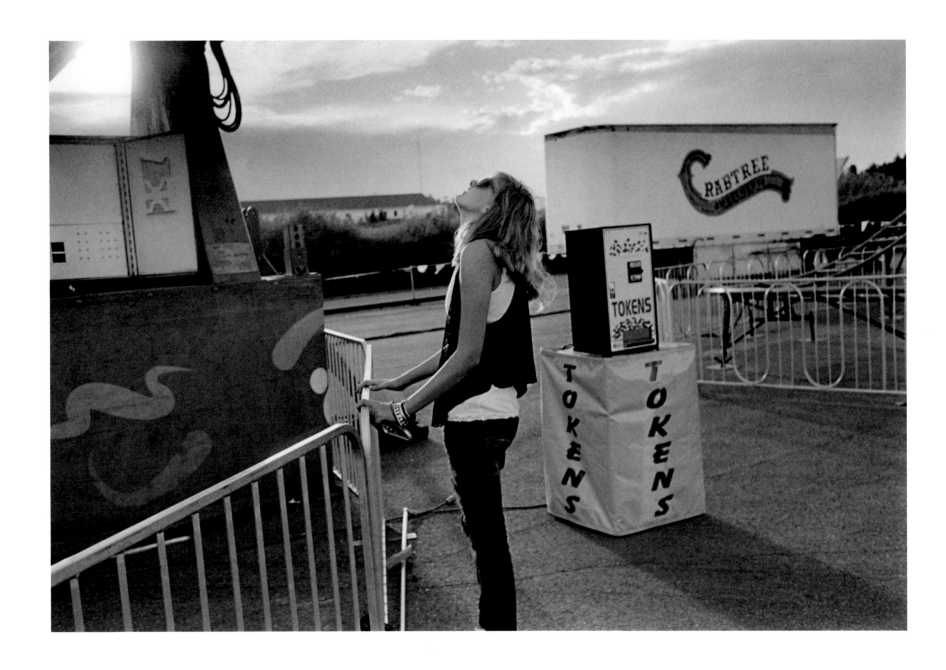

Douglas, Wyoming 2011

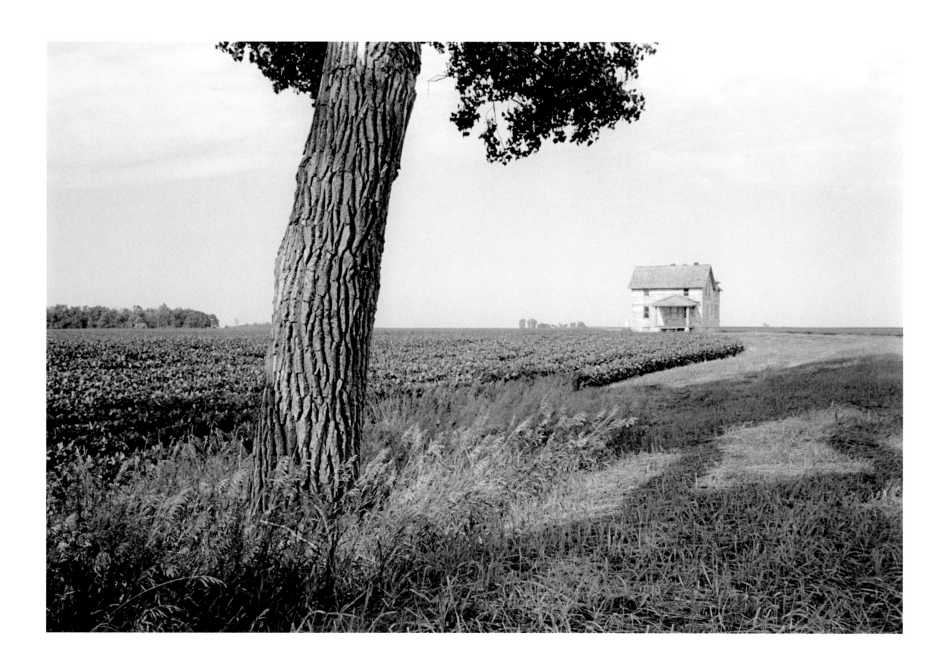

Hutchinson County, South Dakota 2014

AFTERWORD

Rick Bass

What is the West? We think we know—cowboys, Indians, cows, dust, sunsets, rodeos, right? One of the many things that is powerful about these photographs by Peter Kayafas is the cunning yet also unpretentious way in which the old memes are shown to be secondary to the primal power of youth, and youth in a western landscape.

Like a forced move in a designed space, young people and animals—the currency of the West—continue to produce, almost effortlessly, the same story, or some iteration of it, generation after generation.

The West is a place where the myth of innocence can be preserved a bit longer, where time seems to behave a little differently.

In these photographs two dominant elements—youth and animals—are passing through the landscape of the American West. These twinned elements seem to move sometimes like sleepwalkers lost in a

dream that was never quite birthed into reality. The animals as well as people—particularly the young people—still possess a primal power, but many appear also to be just at the edge of being aware for the first time in their lives of something that might be about to go away.

There are so many things in the world for which there is no one word, or for which even an assemblage of words is insufficient, for the same words can mean different things to different people at different times in their lives. As does the light that shines upon these subjects—animals, young people, old people, inanimate structures. The light is not quite democratic but instead is disproportionately reflective, or shadowed, at any one moment.

It is not a particularly novel observation that we are essentially swimming through light, in each waking hour; and one of the things I think I see in the people portrayed here is the dawn of first awareness of not just transience, but the increasing acceleration of time that seems to be paired with that first realization of transience. All travelers are, by the nature of time, moving forward. Sometimes, in so doing, they move away from that light; other times, they lean deeper into it: but regardless, everything is changing.

The light seems innocuous—it simply falls on us, appears to have no negative effects. And yet, buildings delaminate, people trudge toward senescence, animals come and go, powering us ever forward, and—there are boundaries. As a child, one might not initially have seen this phenomenon, but I do believe the young people in these photographs are just starting to figure out these mechanics of boundaries

and borders. In *The Way West*, they can smell it, feel it, hear it, taste it—this new perception that something beyond them is traveling alongside them, *time*, and at a decidedly different pace, and yet they are not frightened. It could be said they are even hopeful. It could be said they are even courageous and thoughtful.

To have captured this unsolvable disparity between not-knowing and first-knowing is, well, pretty incredible. Like capturing on film the elusive boson particle, or, even less identifiable, one of the key filaments of the human soul.

So the photographs herein seem to capture acutely an existence that is obligated to be attentive to the ever-encroaching boundaries of time. Soon the animals will be consumed, and soon the children will be consumed by adulthood. And consumed as well, in many cases, by the loss of something as vital as it is ineffable. And yet, like any great artist, the photographer here searches for that thing; he hunts it, I think.

I have a secret, wrote the poet H. D., *I am alive*. Here in the West we exist with a similar secret; we each carry within us an often-thumping joy and despair, the amplitudes of which usually only seem outsized when we find ourselves in the company of non-Westerners. By no means of course do we corner the market on these amplitudes: but I believe strongly that our environment—our relationship to time and space—is extraordinarily fertile for growing and attenuating such amplitudes. To me, then, that's one of the most haunting things about this collection: that Kayafas, and no matter really whether through

design or happenstance, has identified and portrayed subjects who are poised—in some cases, almost huddled—between those far points, the human wayposts of joy or despair.

Is there greater safety, in that middle? I do not believe so. Though neither do I judge the subjects for their sometimes-muted and cautious positions: a tentativeness. Fear is an effective, even dominant con-strainer. And certainly there is a great deal that is alarming—much of it on the horizon, but much of it having already arrived.

In his novel *No Country for Old Men*, Cormac McCarthy refers to "the fire in the horn"—a nest of sparks carried in a cow or buffalo horn to help facilitate the starting of a campfire whenever the traveler arrives at each day's-end destination. A thing that is tended, protected in one's travels, and which is never allowed to go out.

We see in the often sleepy-lidded pondering silences of the young people here—the next wave of humanity that will be inhabiting, and shaping, and being shaped by, the West—an internal reckoning as well as the ancient and competing tendencies to sometimes gather together as if in a herd, though other times they are dispersed, isolated, and indi-vidual. Rarely here do the young people seem to be visiting or convers-ing, but instead existing between words. A penny for their thoughts. Though their gaze never seems to fall on the fences that surround and bound them, it seems to me a case can be made that in their close scru-tiny of the domestic stock that is often the currency of their lives, and in their similar scrutiny of each other, there is a part of them that is doing the math, thinking, *What does the future hold?* The world—even in the

great West, which we have been told to believe is limitless—is not limitless, and may well be getting smaller; the fences might be tightening up, moving closer. And yet: they have a core. For a while, they feasted on the myth of timelessness, and the memory of that feast will stay with them all, old and young, always, no matter the journey ahead.

We understand domestic stock serves a multiplicity of purposes—sustenance, of course, and companionship; but many of these photographs help open a portal to another dimension as well: a semipermeable, organic, living barrier between the amplitudes of a time-and-place of wildness (by which I mean that which cannot be controlled) and a time-and-place of tameness, as exemplified by all that which can be controlled, and is.

The animals here are placeholders, markers of that strandline between the two; as is adolescence. As is indeed the present-day West itself, wavering back and forth between past and future.

This, too: the boundaries in these photographs are often hard. There is a complicated weave at play here in the negotiations of a transaction that is essentially non-negotiable. For each of these subjects, as it is for each of us, the moment is melting, even as we behold it. Even as the photographer beholds it. This is an old axiom of art, and perhaps most familiarly in photography—but even so, these images seem to carry an even larger dose of the eternal melting, eternal slipping-away. We could discuss for eons whether this is an observation by the photographer, or a bias—

a predisposition to search for and find these things. We could argue whether it is both observation and bias, or neither, or both, or neither.

What is the nature of landscape in the effects upon these wan negotiations? Time-versus-space: this is the equation, the formula, that has yielded all cultures and societies, and certainly, that is the case in the West. Beholding these images embedded in sky, heat, aridity, and space, one might just as well be asking, What are the key ingredients for loneliness, and what, if any, are the antidotes?

Consider the pronghorn behind glass ("Established 1983"!). The poetic phrasing of Robinson Jeffers comes to mind, a pithy and elegant telling of evolutionary biology: "What but the wolf's tooth whittled so fine / The fleet limbs of the antelope?" The answer is of course the North American cheetah, now extinct, even as the cheetah's ghost, the pronghorn, still races across the plains, preposterously faster than any other remaining predator: haunted now with what many might call waste or excess, while others might call it beauty, or even art.

Two pages, left-facing and right-facing: stuffed antelope and vibrant cutting horse, both are bounded, constrained. The sun-faded Styrofoam pronghorn is trapped in his glassine streetside display case, while the powerful quarterhorse is confined by the fences and rails that are the frequent backdrop for so many of these images.

What is the antidote to this dawning awareness? Surely, the same as it ever was, play. Whether it be in the rituals of the carnival, festival,

rodeo, parade, whatever, or the freeform spontaneity more favored by clumps and clusters of young people, we thirst for play, we hunger for play—and here, too, soul-peering, Kayafas identifies more filaments of the human condition as we travel briefly in all this light. I think we see these things in the light that surrounds the subjects. Is it emanating from them, or falling, shining, upon them?

Obviously, not all is pie and county fair. The brittle anger, the stiffness that precedes rage and its contained or imprisoned close cousin, depression, is here, too—the dusty stupefaction of the human condition. We see it in the sometimes desperate, primal groping of touch, the sweet and heroic attempts to ground ourselves in the whirling passage of our journeys—touching one another, or an animal, or even, abstractly, ourselves, in a gesture of mute fidelity: hand-to-heart, or hat-from-brow, in the habit or custom of respect.

It is all about to start going by faster, for all of us, but particularly for the youth in these photographs—though passing just as quickly for each of us, as well, viewers as well as subjects. One is not separate from the other. There is a distance between us, but in the West we are not yet separated from the world. These photographs are filaments of light that connect us to strangers who, though strange, are as recognizable as they are unfamiliar. They still have the fire in the horn. Which is to say, each still and always possesses an inextinguishable beauty.

Acknowledgments

This publication was made possible by the generosity and support of: Heather Althoff and Don Bailey; David J. Baker; Adam Bartos; Dorothy Blackmun; Arthur Collins; Rufus Collins; Paola Dal Cin; Susan and Thomas Dunn; David Falk; Mary Frank; Elizabeth Gaffin; Peter Galassi; Sharon Helgason Gallagher; Tom Gitterman; Stephen Hilger; Jamie Johnston; Arlette and Gus Kayafas; Tricia and Jonathan Koff; Danny Kopel; Nancy Lassalle; Joyce Linde; Frank Mockler and Stephen Griffin; Elisa Nadel; Tommy Nohilly; Thomas Osborne and Scott Benaglio; Jed Perl; Raymond Schrag; Emily Shanahan; Sarah Shepard; Stephen Shore; Margo and Anthony Viscusi; Sasha Wolf; and the John Simon Guggenheim Memorial Foundation.

Editing and sequencing by Peter Kayafas and Sasha Wolf
Design and typography by Julie Fry
Printing by The Studley Press, Suzanne Salinetti and Scott Artioli
Binding by Superior
Set in Miller and Swiss

ISBN 978-0-9797768-3-0
LCCN 2019939623